FRANK

ON THE PRAIRIE

Profits from the sale of the illustrated edition of this book will be
dedicated to establishing an expanded endowment supporting the
C.M. Russell Museum, whose mission is
To collect, preserve, research, interpret, and educate on the art and
life of Charles M. Russell; the art and lives of his contemporaries; and
the art of preceding and ensuing generations that depicts and focuses
on the culture, life, and country of Russell's West.

FRANK

ON THE PRAIRIE

By HARRY CASTLEMON

Additional Illustrations by
CHARLES M. RUSSELL

Introductions by
THOMAS A. PETRIE AND THOMAS MINCKLER

C.M. Russell Museum

Great Falls, Montana

Library of Congress Cataloging-in-Publication Data

Names: Castlemon, Harry, 1842–1915, author. | Russell, Charles
M.(Charles Marion), 1864–1926, illustrator.
Title: Frank on the Prairie / by Harry Castlemon ; additional illustra-
tions by Charles M. Russell ; introductions by Thomas A. Petrie and
Thomas Minckler. Description: Great Falls, Montana : C.M. Russell
Museum, 2017.
Summary: For months after their return from a hunting expedition,
Frank and Archie talked of nothing else, until one day their thoughts
and conversation turned to the arrival of an uncle, who had just
returned from California.
Identifiers: LCCN 2016040261 | ISBN 978-0-8061-5743-6 (hardcover :
alk. paper) Subjects: | CYAC: Adventure and adventurers—Fiction.
| Friendship—Fiction. | Hunting—Fiction. | West (U.S.)—Fiction.
Classification: LCC PZ7.F786 Frp 2017 | DDC [Fic]—dc23LC record
available at https://lccn.loc.gov/2016040261

1 2 3 4 5 6 7 8 9 10

INTRODUCTION

In 1903 Charles Marion Russell, the "Cowboy Artist," presented a special gift to his nephew Austin Russell. Austin had among his books a boy's adventure tale titled *Frank on the Prairie*. This was one of six volumes in what became known as The Gunboat Series, by Harry Castlemon, a pen name for Charles Austin Fosdick (1842–1915). Borrowing the book, Russell later returned it with beautifully illustrated pages featuring eleven original watercolors and one pencil drawing. Several of these were exquisite, and all of them powerfully brought to life the book's key characters and highlighted the story's plot. In the essay following, Thomas Minckler, a Montana collector of and dealer in art, rare books, and artifacts, provides a perspective on each of these works of art.

As Minckler observes, Russell illustrated a number of books over the years that were typically published with reproductions of pen-and-ink images. Rarely would he illustrate a single volume with unique original watercolor images. Most notably, on three occasions Russell provided original watercolor images for individual copies of Francis Parkman's 1849 classic, *The Oregon Trail*.

These are interesting in relation to the images contained in Austin Russell's copy of *Frank on the Prairie,* because Castlemon's book in many ways represents an analogous fictional account of similar adventures experienced by two boys who follow a route roughly parallel to that of Parkman while on their own trip west.

Castlemon set his story in the period when Charlie Russell was growing up in St. Louis, before he headed west to Montana in 1880 at the age of fifteen. Coincidentally, this city was close to the point of departure for Frank and his fellow western travelers. Furthermore, in her unpublished biography of her husband, Russell's wife, Nancy, states that Charlie's father, Charles Silas Russell, often read to him and his siblings "for an hour every night. He read the 'Frank Stories' and histories of Crockett, Boone, and Kit Carson. All of these stories the boys adored."

There is other evidence of Charlie Russell's familiarity with the writings of Harry Castlemon. As Russell scholar Brian Dippie notes, five editions of the Frank series (including the first, *The Young Naturalist*) were and are today in the Russell Studio Collection at the C.M. Russell Museum (CMRM) in Great Falls, Montana. Also present are three other books by Harry Castlemon.

Interestingly, "among CMR's books in the studio collection at the CMRM," Dippie also notes, "several are later printings, three in dust jackets and apparently unread, and three dated in ink, C.M. Russell/March 19th, 1907." It may be noteworthy that the date given is Charlie's birthday. "The copies in fine condition," Dippie adds, "may well have been presents of books that CMR had already read." In any case, the Frank book series clearly had special meaning to Russell.

Like Parkman in *The Oregon Trail*, Frank and his friend Archie never get as far west as Oregon. Instead, they cross Missouri on horseback with an accompanying wagon and proceed on to the Nebraska plains. They then experience a series of adventures, mishaps, and challenges in the territories now constituting Colorado and Wyoming. Strikingly similar to Parkman's account, they encounter mountain men, antelope, bears, and wild horses and have adventures involving Indians, outlaws, and a river crossing. In the book, Russell's image of a bear near its cave is highly evocative of scenes he had depicted in drawings done earlier at the age of fourteen or fifteen that are now included in *Boyhood Sketches,* by R. D. Warden (pages 7 and 9). A buffalo hunt depiction is also particularly reminiscent of Parkman's account

and of similar accounts by Russell's friend James Willard Schultz. A white man adopted into the Blackfeet tribe, Schultz wrote of his own experience hunting buffalo that closely resembles the tale of Frank's buffalo encounter. After reading Shultz's accounts of the athleticism and split-second decision making required to survive the extreme dangers and chaos of Indian buffalo hunting, it is difficult to ever again view Russell's painting of such events quite the same way. This is especially true of the two buffalo-related images in this volume.

In another incident, Frank, as in artist Alfred Jacob Miller's *The Lost Greenhorn*, becomes lost on the prairie and endures a Parkmanesque night of listening to the howling of wolves. Subsequently, Frank has a run-in with desperados who rob him of his horse, saddle, gun, and other equipment, leaving him destitute on the plains. All in all, *Frank on the Prairie* can be viewed as a fictional version for boys of Parkman's *Oregon Trail*.

In this context, Harry Castlemon writes in "How I Came to Write My First Book":

When I was sixteen years old I belonged to a composition class. It was our custom to go on the recitation seat every day with clean slates, and we were allowed ten minutes to write seventy words on any subject. . . . The teacher

listened to the reading of our compositions, and when they were all over he simply said: "Some of you will make your living by writing one of these days." That gave me something to ponder upon, I did not say so out loud, but I knew that my composition was as good as the best of them. . . . I went home that very day and began a story which was sent to the *New York Weekly*, and came back, respectfully declined. . . . Nothing abashed, I began another, and receiving some instruction, from a friend of mine who was a clerk in a book store, I wrote it . . . [and] one day, after a hard Saturday's work—the other boys had been out skating on the brick-pond—I shyly broached the subject to my mother. I felt the need of some sympathy. She listened in amazement, and then said: "Why, do you think you could write a book like that?" That settled the matter, and from that day no one knew what I was up to until I sent the first four volumes of Gunboat Series to my father. Was it work? Well, yes; it was hard work, but each week I had the satisfaction of seeing the manuscript grow until the "Young Naturalist" was all complete.

In many ways Castlemon's subsequent volumes of boys' adventure books paralleled the focus and output of Horatio

Alger Jr. Alger famously wrote stories about youths overcoming adversity in honorable pursuit of "American dreams," almost always involving challenging endeavors and tests of character. His literary legacy lives on today in a foundation bearing his name and dedicated to inspiring and honoring individuals whose lives epitomize the themes he chronicled. Alger and Fosdick (as Castlemon) each produced more than forty volumes intended to broaden youthful horizons and inspire a sense of morality and an extraordinary work ethic. Interestingly, books by both Alger and Fosdick were cross-marketed with ads for each other's publications in the back of the books. Alger's first book, *Ragged Dick, or Street Life in New York*, appeared in 1868 and made him famous. He then expanded it into a series of six volumes with an estimated sale of 200,000 copies, a phenomenal best seller for that era. Sales of the book even approached the level of marketing success attained by the memoirs of Ulysses S. Grant.

All this occurred during the latter half of the nineteenth century, when young boys were coming of age in the aftermath of the Civil War's devastation. They were experiencing the pressures of urbanization and changing social settings. American society began to be transformed by the inventions of Alexander Graham Bell, Thomas

Edison, and their peers and the subsequent industrial innovations of Henry Ford and others. Urbanization and industrialization contributed to a loss of connection with the natural world and a yearning for the vanishing western frontier.

In an article titled "Writing Stories for Boys," Alger wrote, "A writer for boys should have an abundant sympathy with them. He should be able to enter into their plans, hopes, and aspirations. He should learn to look upon life as they do. Boys object to be written down to. A boy's heart opens to the man or writer who understands him." This writing philosophy is strikingly consistent with what Castlemon sought to achieve and what undoubtedly resonated for both Charlie and Austin Russell in their readings of his work. While many of Alger's stories dealt with eastern settings, Castlemon's Frank series generally, and especially his *Frank on the Prairie*, fully measures up to Alger's purpose in writing for youth, but with a decidedly western focus.

As the United States moves well into the second decade of what is now an even more highly urbanized and technologically driven century, this boy's outdoor adventure story remains relevant to today's youthful readers, whose development and character are still being

shaped by the many challenges of this rapidly evolving digital age. But "virtual reality" can take a person only so far. As the Ken Burns documentary *The National Parks: America's Best Idea* underscores, "actual reality" based on experiences in the physical and natural world still counts heavily in effective human development, as do well-constructed tales relating such events. Having personally seen the role that nature, and even wilderness settings, can play in nurturing the human soul, I believe this new edition of a timeless book has much to offer, enlivened as it is with Charlie Russell's images that make the text come alive.

As Charlie once observed and Harry Castlemon demonstrated:

The West is Dead My Friend
But Writers Hold The Seed
And What They Sow
Will Live and Grow
Again To Those Who Read.

Castlemon's original text includes a few passages that, while more commonplace in their day, would and should be identified as denigrating to ethnic and racial minorities, especially African Americans, today. Rather than try to impose censor-

ship on a text created and published almost a century and a half ago, Castlemon's text is presented here, in the interest of historical accuracy, as he originally wrote and published it. This reproduction of the text, verbatim as it appeared originally, does not reflect the sensibilities of this author or the publisher. Quite the contrary.

Thomas A. Petrie
Vice Chairman
C.M. Russell Museum Board of Directors

A COLLECTOR'S PERSPECTIVE ON THE IMAGES IN CHARLIE RUSSELL'S EXTRA-ILLUSTRATED COPY OF *FRANK ON THE PRAIRIE*

One of Charlie Russell's favorite writers was Harry Castlemon, and his favorite nephew was Austin Russell, son of his brother, Bent. Castlemon, a pen name for Charles Austin Fosdick, was a prolific writer who wrote *Frank on the Prairie*, part of The Gunboat Series of Books for Boys, first published in 1868. Austin Russell lived with the Russells in Great Falls from 1908 to 1916 and had made several trips to Bull Head Lodge, their summer retreat in Glacier Park. Austin later penned an intimate biography of his uncle that was published in 1957. In *Charles M. Russell: A Biography*, Austin wrote, "Russell took an old fashioned boys' book of mine and extra illustrated the chapter headings and tail pieces with very small figures of Indians, trappers, and animals." He added, "If left to himself, Charlie was not very practical; he would devote just as much care to things not meant to sell." This extra-illustrated 1893 edition of the book is by far one of Russell's most personalized works of art.

Charlie Russell created in this volume one of the single most important works of art in the significant collection that Frederic G. and Ginger K. Renner amassed over more than forty years. He painted a series of watercolors that are true gems, representing some of the best miniature works of art he ever accomplished. Nearly Russell's entire genre is embodied in this single book: the regal American Indian, a pitched Indian battle of counting coup, the fur trader, wildlife, an iconic buffalo hunt, a buffalo stampede, the outlaw, frontier portraits, a nighttime camp scene, a tomahawk peace pipe, and a wild horse herd—all meticulously drawn and painted. Every image is in its original condition as if painted just yesterday.

Russell added eleven watercolors and one pencil sketch to Austin's copy of *Frank on the Prairie*. The initial watercolor heading for Chapter 1 is a charming drawing of three mounted Indians at sunset with their figures reflected in a nearby stream. It is signed and dated "C.M. Russell, 1903." Notably, in that same year, George Calvert built a log cabin next to the Russell home on Fourth Avenue North in Great Falls to serve as a studio and retreat where Charlie could paint. Perhaps he was encouraged and inspired by this rustic atmosphere; but whatever

the case, 1903 marked the beginning of Russell's mature artistic period of painting. His use of color and his choice of subject matter vastly improved, showcasing the genius of his artistry and his perception of the changing times.

Each drawing Russell placed in the book is a stand-alone work of art. Together, the illustrations represent a collection of his best subject matter. Russell first read the book, then drew small pencil sketches, placing them in context. After that he used watercolors to create a series of artworks that perfectly narrate the story. The wildlife scenes represent a grizzly bear at his den, an antelope head with a paint fingerprint left by Russell, and a poignant piece titled "A Night Among the Wolves." In another, a startled trapper sits by a campfire, rifle in hand, alerted to the presence of two wolves, eyes gleaming and outlined by a full moon. "The King of the Drove" illustrates a story about the capture of the lead stallion of a wild horse herd. This full watercolor depicts the herd in front of a Glacier National Park backdrop.

The "Buffalo Hunt" is the iconic subject matter of Russell's oeuvre. The 3½ x 5–inch watercolor, the book's masterpiece, shows a warrior closing in on a stampeding buffalo bull. It is followed by "Frank's Buffalo Stampede Escape," the account of a harrowing escape from a

rampaging buffalo herd. There are two portraits, one of an old-time trapper who guided Frank and his companions West, and the other of the outlaw and horse thief Black Bill. In addition, two charming illustrations of the Plains Indian portray a beautifully detailed warrior mounted on a white horse and, as depicted on this edition's dust jacket, a "Counting Coup" battle on horseback between a trapper and an Indian. A single pencil sketch of a mounted party leaving a fort reveals how the artist worked. After returning the book to Austin, he probably inadvertently neglected to color the twelfth piece.

Provenance outlines where an object originated and was nurtured during its early existence. The importance of provenance is never more enhanced than by the lineage and significance of its owners. This is especially true in the world of art and collectibles. The Castlemon book is signed twice by Austin Russell, who died shortly after publication of his Russell biography in 1957. The Renner provenance is significant for many reasons. Chief among them is the Renners' expertise and lifelong study of the artist; in their time they were the acknowledged experts on Charlie Russell. Fred Renner, who grew up in Great Falls a mere four blocks from Russell's studio, occasionally visited the artist there to watch him paint.

Renner's earliest recollection was seeing the construction of the log cabin studio, the year he entered first grade. Although Renner left Great Falls in 1911, his time there represented the start of a lifelong passion for collecting and gathering paintings, books, and memorabilia on the "Cowboy Artist." He visited Nancy Russell in the 1930s and eventually became the leading authority on the artist. After Fred's first wife, Maxine, passed away, he later met and married Ginger Neveau in 1973. Their union immeasurably nurtured scholarship on Charlie Russell.

Russell rarely extra-illustrated books. Besides the Castlemon/Austin Russell book, the other known books to which he added illustrations are listed by the Russell scholar and writer Brian W. Dippie in his 1993 book, *Charles M. Russell, Word Painter: Letters, 1887–1926*. They include the Armstrong copy of the *Oregon Trail* in the Rockwell Museum; Agnes Laut's *Story of the Trapper* (for Berners Kelly); Charles Dickens's *American Notes* (for Frank Nankivell); Mark Twain's *A Connecticut Yankee in King Arthur's Court* for Josephine Trigg, which now resides in the C.M. Russell Museum; and two other copies of Parkman's *Oregon Trail* for Percy Raban and Howard Vanderslice. The Castlemon book *Frank on the*

Prairie is featured in Larry Peterson's book *Charles M. Russell: Legacy*, published in 1999. A few of the images are reproduced on pages 160–162. Russell's last illustrated book was a unique copy of Anges Laut's *The Blazed Trail of the Old Frontier*, presented to Ralph Budd, president of the Great Northern Railroad, on the occasion of the Columbia River Historical Expedition in 1926, with an original watercolor of a mounted Indian warrior. It is the frontispiece in Peterson's book.

Much has been written about Charlie Russell and the life he lived and portrayed in Montana, but much of it can be witnessed visually firsthand in this faithful reproduction of the iconic Castlemon/Austin Russell extra-illustrated book.

Thomas Minckler

What follows is a full facsimile of the 1893 edition of *Frank on the Prairie*, including the series and title pages of the publisher, Henry T. Coates & Company, Philadelphia, and even its advertisements for other books for boys and girls.

The GUNBOAT SERIES

Books for Boys,

by a GUNBOAT BOY

FRANK,

ON THE PRAIRIE.

HENRY T. COATES & CO.
PHILADELPHIA.

FRANK AND ARCHIE SERIES.

FRANK

ON THE PRAIRIE

BY

HARRY CASTLEMON,

AUTHOR OF "THE ROCKY MOUNTAIN SERIES," "THE GO-AHEAD
SERIES," ETC.

PHILADELPHIA
HENRY T. COATES & CO.

FAMOUS CASTLEMON BOOKS.

GUNBOAT SERIES. By HARRY CASTLEMON. 6 vols. 12mo.

FRANK THE YOUNG NATURALIST. FRANK ON A GUNBOAT.
FRANK IN THE WOODS. FRANK BEFORE VICKSBURG.
FRANK ON THE LOWER MISSISSIPPI. FRANK ON THE PRAIRIE.

ROCKY MOUNTAIN SERIES. By HARRY CASTLEMON. 3 vols. 12mo. Cloth.

FRANK AMONG THE RANCHEROS. FRANK AT DON CARLOS' RANCH.
FRANK IN THE MOUNTAINS.

SPORTSMAN'S CLUB SERIES. By HARRY CASTLEMON. 3 vols. 12mo. Cloth.

THE SPORTSMAN'S CLUB IN THE SADDLE.
THE SPORTSMAN'S CLUB AFLOAT.
THE SPORTSMAN'S CLUB AMONG THE TRAPPERS.

FRANK NELSON SERIES. By HARRY CASTLEMON. 3 vols. 12mo. Cloth.

SNOWED UP. FRANK IN THE FORECASTLE. THE BOY TRADERS.

BOY TRAPPER SERIES. By HARRY CASTLEMON. 3 vols. 12mo. Cloth.

THE BURIED TREASURE. THE BOY TRAPPER. THE MAIL-CARRIER.

ROUGHING IT SERIES. By HARRY CASTLEMON. 3 vols. 12mo. Cloth.

GEORGE IN CAMP. GEORGE AT THE WHEEL. GEORGE AT THE FORT.

ROD AND GUN SERIES. By HARRY CASTLEMON. 3 vols. 12mo. Cloth.

DON GORDON'S SHOOTING BOX. ROD AND GUN CLUB.
THE YOUNG WILD FOWLERS.

GO-AHEAD SERIES. By HARRY CASTLEMON. 3 vols. 12mo. Cloth.

TOM NEWCOMBE. GO-AHEAD. NO MOSS.

FOREST AND STREAM SERIES. By HARRY CASTLEMON. 3 vols. 12mo. Cloth.

JOE WAYRING. SNAGGED AND SUNK. STEEL HORSE.

WAR SERIES. By HARRY CASTLEMON. 5 vols. 12mo. Cloth.

TRUE TO HIS COLORS. RODNEY THE PARTISAN.
RODNEY THE OVERSEER. MARCY THE BLOCKADE-RUNNER.
MARCY THE REFUGEE.

Other Volumes in Preparation.

Contents.

(vii)

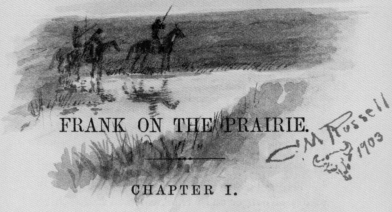

FRANK ON THE PRAIRIE.

CHAPTER I.

Ho for the West!

OR two months after their return from their hunting expedition in "the woods," Frank and Archie talked of nothing but the incidents that had transpired during their visit at the trapper's cabin. The particulars of Frank's desperate fight with the moose had become known throughout the village, and the "Young Naturalist" enjoyed an enviable reputation as a hunter. He was obliged to relate his adventures over and over again, until one day his thoughts and conversation were turned into a new channel by the arrival of an uncle, who had just returned from California.

Uncle James had been absent from home nearly ten years, and during most of that time had lived in the mines. Although the boys had not seen him since they were six years old, and of course could not remember him, they were soon on the best of terms with each other. Uncle James ha l an inexhaustible fund of stories; he had crossed the plains, fought the Indians, was accustomed to scenes of danger and excitement, and had such an easy way of telling his adventures, that the boys never grew tired of listening to them. The day after his arrival he visited the museum, gazed in genuine wonder at the numerous specimens of his nephews' handiwork, and listened to the descriptions of their hunting expeditions with as much interest as though he had been a boy himself. Then he engaged in hunting with them, and entered into the sport with all the reckless eagerness of youth.

The winter was passed in this way, and when spring returned, Uncle James began to talk of returning to California to settle up his business. He had become attached to life in the mines, but could not bear the thought of leaving his relatives again. The quiet comforts he had enjoyed

at the cottage he thought were better than the rough life and hard fare to which he had been accustomed for the last ten years. He had left his business, however, in an unsettled state, and, as soon as he could "close it up," would return and take up his abode in Lawrence. The cousins regretted that the parting time was so near, for they looked upon their relative as the very pattern of an uncle, but consoled themselves by looking forward to the coming winter, when he would be settled as a permanent inmate of the cottage.

"I say, Frank," exclaimed Archie one day, as he burst into the study, where his cousin was engaged in cleaning his gun preparatory to a muskrat hunt, "there's something in the wind. Just now, as I came through the sitting-room, I surprised our folks and Uncle James talking very earnestly about something. But they stopped as soon as I came in, and, as that was a gentle hint that they did n't want me to know any thing about it, I came out. There's something up, I tell you."

"It's about uncle's business, I suppose," replied Frank. But if that *was* the subject of the

conversation, Archie came to the conclusion that
his affairs must be in a very unsettled state, for
when they returned from their hunt that night
the same mysterious conversation was going on
again. It ceased, however, as the boys entered
the room, which made Archie more firm in his be-
lief than ever that there was "something up."

The next morning, at the breakfast-table, Ar-
chie's father announced his intention of returning
to Portland at once, as his business needed his
attention; and, turning to the boys, inquired:

"Well, have you had hunting enough this win-
ter to satisfy you?"

"Yes, sir," was the answer.

"Then I suppose you don't want to go across
the plains with your Uncle James?"

"Hurrah!" shouted Archie, springing to his
feet, and upsetting his coffee-cup. "Did you say
we might go?"

"Be a little more careful, Archie," said his
father. "No, I did not say so."

"Well, it amounts to the same thing," thought
Archie, "for father never would have said a word
about it if he wasn't intending to let us go. I
knew there was something up."

We need not stop to repeat the conversation that followed. Suffice it to say, that Uncle James, having fully made up his mind to return to the village as soon as he could settle up his business, had asked permission for his nephews to accompany him across the plains. Their parents, thinking of the fight with the moose, and knowing the reckless spirit of the boys, had at first objected. But Uncle James, promising to keep a watchful eye on them, had, after considerable argument, carried the day, and it was finally decided that the boys could go.

"But remember," said Mr. Winters, "you are to be governed entirely by Uncle James; for, if you have no one to take care of you, you will be in more fights with bears and panthers."

The boys readily promised obedience, and, hardly waiting to finish their breakfast, went into the study to talk over their plans.

"Didn't I tell you there was something up?" said Archie, as soon as they had closed the door "We'll have a hunt now that will throw all our former hunting expeditions in the shade."

As soon as their excitement had somewhat abated, they remembered that Dick Lewis, the

trapper, had told them that it was his intention to
start for the prairie in the spring. If he had not
already gone, would it not be a good plan to se-
cure his company? He knew all about the prairie,
and might be of service to them. They laid the
matter before Uncle James, who, without hesita-
tion, pronounced it an excellent idea. "For,"
said he, "we are in no hurry. Instead of going
by stage, we will buy a wagon and a span of
mules and take our time. If we do n't happen to
fall in with a train, we shall, no doubt, want a
guide." As soon, therefore, as the ice had left
the creek so that it could be traveled with a boat,
Uncle James accompanied the boys to the trap-
per's cabin.

Dick met them at the door, and greeted them
with a grasp so hearty, that they all felt its effects
for a quarter of an hour afterward.

"I ain't gone yet," said he; "but it won't be
long afore I see the prairy onct more."

"Well, Dick," said Frank, "we 're going, too,
and want you to go with us."

The trapper and his brother opened their eyes
wide with astonishment, but Uncle James explained,
and ended by offering to pay the trapper's ex-

poses if he would accompany them. After a few moments' consideration, he accepted the proposition, saying:

"I have tuk to the youngsters mightily. They're gritty fellers, an' I should like to show 'em a bit of prairy life."

Uncle James and the boys remained at the cabin nearly a week, during which their plans were all determined upon, and, when they arrived at home, they at once commenced preparations for their journey. Their double-barreled shot-guns were oiled, and put carefully away. They were very efficient weapons among small game, but Uncle James said they were not in the habit of using "pop-guns" on the prairie; they would purchase their fire-arms and other necessary weapons at St. Louis.

The first of June—the time set for the start—at length arrived, and with it came the trapper, accompanied by his dog. Dick carried his long rifle on his shoulder, his powder-horn and bullet-pouch at his side, and a knapsack, containing a change of clothes and other necessary articles, at his back. He had evidently bestowed more than usual care upon his toilet; his suit of buckskin

was entirely new, and even his rifle seemed to
have received a thorough rubbing and cleaning
preparatory to its introduction into civilized life.
Frank and Archie meeting him at the door, re-
lieved him of his rifle and pack, and conducted him
into the house. But here the trapper was sadly
out of place. He sat on the edge of his chair,
and was constantly changing the position of his
feet, and looking down at the rich carpet, as if he
could hardly believe that it was made to walk
upon. The inmates of the cottage used every ex-
ertion in their power to make him feel at his ease,
and, to some extent, succeeded; but he breathed
much more freely when the farewells had been
said, and the party was on its way to the wharf.
In due time they arrived at Portland, where they
remained nearly a week. Here the trapper again
found himself in hot water. He was installed in
a large, airy room in Mr. Winter's elegant resi-
dence; but he would much rather have been as-
signed quarters among the trees in the yard. The
sights and sounds of the city were new to him,
and at every corner he found something to wonder
at. When on the street, he was continually get-
ting in somebody's way, or being separated from

his companions, who found it necessary to keep a vigilant watch over him. But it was on the train that his astonishment reached its height. He had never before traveled in the cars, and, as they thundered away, going faster and faster as they left the city behind, the trapper began to clutch his seat, and to look wistfully out the window at the woods, which appeared to be dancing by, as if he never expected to be permitted to enter his natural element again. He would have preferred to "foot it," as he remarked, and, when at last they reached St. Joseph, he drew a long breath of relief, mentally resolving that he would never again tempt destruction by traveling either on a steamboat or railroad car.

It was midnight when they reached the hotel. Being very much fatigued with their long journey, they at once secured rooms and retired, and were soon fast asleep.

2

CHAPTER II.

The Wagon Train.

N awaking the next morning, the boys found themselves surrounded by new scenes. While they were dressing, they looked out at the window, and obtained their first view of a wagon train, which was just starting out for the prairie. The wagons were protected by canvas covers, some drawn by oxen, others by mules, and the entire train being accompanied by men both on foot and on horseback. Fat, sleek cows followed meekly after the wagons, from behind whose covering peeped the faces of women and children—the families of the hardy pioneers now on their way to find new homes amid the solitude of that western region.

The boys watched the train until it disappeared, and then went down stairs to get their breakfast.

Uncle James was not to be found. In fact, ever since leaving Portland, he seemed to have forgotten his promise to his brother, for he never bothered his head about his nephews. It is true, he had watched them rather closely at the beginning of the journey, but soon discovered that they were fully capable of taking care of themselves and the trapper besides. He did not make his appearance until nearly two hours after the boys had finished their breakfast, and then he rode up to the hotel mounted on a large, raw-boned, ugly-looking horse. He was followed by the trapper, who was seated in a covered wagon, drawn by a span of mules, while behind the wagon were two more horses, saddled and bridled.

"Now, then, boys," said Uncle James, as he dismounted and tied his horse to a post, "where's your baggage? We're going with that train that went out this morning."

"An' here, youngsters," exclaimed Dick, as he climbed down out of his wagon, "come an' take your pick of these two hosses. This one," he continued, pointing to a small, gray horse, which stood impatiently pawing the ground and tossing his head—"this feller is young and foolish yet. He

do n't know nothin' 'bout the prairy or buffalcr huntin'; an' if whoever gets him should undertake to shoot a rifle while on his back, he would land him on the ground quicker nor lightnin'. I 'spect I shall have to larn him a few lessons. But this one"—laying his hand on the other horse, which stood with his head down and his eyes closed, as if almost asleep—"he 's an ole buffaler hunter. The feller that your uncle bought him of has jest come in from the mountains. He can travel wusser nor a steamboat if you want him to, an' you can leave him on the prairy any whar an' find him when you come back. Now, youngster," he added, turning to Frank, "which 'll you have?"

"I have no choice," replied Frank. "Which one do you want, Archie?"

"Well," replied the latter, "I 'd rather have the buffalo hunter. He looks as though he had n't spirit enough to throw a fellow off, but that gray looks rather vicious."

"Wal, then, that 's settled," said the trapper; "so fetch on your plunder, an' let 's be movin' to onct."

Their baggage, which consisted of three trunks— small, handy affairs, capable of holding a consider-

able quantity of clothing, but not requiring much space—was stowed away in the wagon. When Uncle James had paid their bill at the hotel, they mounted their horses, and the trapper, who now began to feel more at home, took his seat in the wagon, and drove after the train. Archie soon began to think that he had shown considerable judgment in the selection of his horse, for they had not gone far before the gray began to show his temper. After making several attempts to turn his head toward home—a proceeding which Frank successfully resisted—he began to dance from one side of the street to the other, and ended by endeavoring to throw his rider over his head; but the huge Spanish saddle, with its high front and back, afforded him a secure seat; and after receiving a few sharp thrusts from Frank's spurs, the gray quietly took his place by the side of Archie's horse, and walked along as orderly and gentle as could be wished.

The trapper, who was now the chief man of the party, had superintended the buying of their outfit, and, although it was a simple one, they were still well provided with every necessary article. The boys were dressed in complete suits of blue jeans,

an article that will resist wear and dirt to the last
extremity, broad-brimmed hats, and heavy horse-
man's boots, the heels of which were armed with
spurs.

Their weapons, which were stowed away in the
wagon, consisted of a brace of revolvers and a hunt-
ing-knife each, and Archie owned a short breech-
loading rifle, while Frank had purchased a common
"patch" rifle. The wagon also contained provis-
ions in abundance—coffee, corn meal, bacon, and
the like—and ammunition for their weapons.
Their appearance would have created quite a com-
motion in the quiet little village of Lawrence, but
in St. Joseph such sights were by no means un-
common. Buckskin was much more plenty than
broadcloth, and the people who passed them on
the streets scarcely noticed them.

At length, just before dark, they overtook the
train, which had stopped for the night. The wag-
ons were drawn up on each side of the road, and
altogether the camp presented a scene that was
a pleasant one to men wearied with their day's
journey. Cattle were feeding quietly near the
wagons, chickens cackled joyously from their
coops, men and women were busily engaged with

their preparations for supper, while groups of noisy children rolled about on the grass, filling the camp with the sounds of their merry laughter.

The trapper drove on until he found a spot suitable for their camp, and then turned off the road and stopped. He at once began to unharness the mules, while the boys, after removing their saddles, fastened their horses to the wagon with a long rope, and allowed them to graze. When the trapper had taken care of his mules, he started a fire, and soon a coffee-pot was simmering and sputtering over the flames, and several slices of bacon were broiling on the coals. After supper, the boys spread their blankets out under the wagon, and, being weary with their day's ride (for it was something new to them), soon fell asleep.

The next morning, when they awoke it was just daylight. After drawing on their boots, they crawled out from under the wagon, and found the trapper, standing with his hat off, and his long arms extended as if about to embrace some invisible object.

"I tell you what, youngsters," said he, as the boys approached; "if this aint nat'ral; jest take a sniff of that ar fresh air! Here," he contin-

ued, looking about him with a smile of satisfac-
tion—"here, I know all 'bout things. I'm to
hum now. Thar's nothin' on the prairy that
Dick Lewis can't 'count fur. But, youngsters, I
wouldn't travel on them ar steamboats an' rail-
roads ag'in fur all the beaver in the Missouri
River. Every thing in them big cities seemed to
say to me, 'Dick, you haint got no business here.'
Them black walls an' stone roads; them rumblin'
carts an' big stores, war sights I never seed afore,
an' I never want to see 'em ag'in. I know I was
treated mighty kind, an' all that; but it couldn't
make me feel right. I didn't like them streets,
windin' an' twistin' about, an' allers loosin' a fel-
ler; an' I wasn't to hum. But *now*, youngsters,
I know what I'm doin'. Nobody can't lose Dick
Lewis on the prairy. I know the names of all the
streets here; an', 'sides, I know whar they all
lead to. An' as fur varmints, thar's none of 'em
that I haint trapped an' fit. An' Injuns! I know
a leetle 'bout them, I reckon. It's funny that
them ar city chaps don't know nothin' 'bout what's
goin' on out here; an' it shows that all the larnin'
in the world aint got out o' books. Send one of
'em here, an' I could show him a thing or two he

never heern tell on. But I must be gettin' breakfast, 'cause we'll be off ag'in soon; an' on the prairy every feller has to look out fur himself. You can't pull a ring in the wall here, an' have a chap with white huntin' shirt an' morocker moccasins on come up an' say: 'Did you ring, sir?' An' how them ar fellers knowed which room to come to in them big hotels, is something I can't get through my head. Thar's no big bell to call a feller to grub here. Take one of them city chaps an' give him a rifle, an' pint out over the prairy an' tell him to go an' hunt up his breakfast, an' how would he come out? Could he travel by the sun, or tell the pints of the compass by the stars? Could he lasso an' ride a wild mustang, or shoot a Injun plumb atween the eyes at two hundred an' fifty yards? No! I reckon not! Wal, thar's a heap o' things I couldn't do; an' it shows that every man had oughter stick to his own business. It's all owin' to a man's bringin' up."

While the trapper spoke he had been raking together the fire that had nearly gone out; and having got it fairly started, he began the work of getting breakfast. The boys, after rolling up their blankets and packing them away in the wagon,

amused themselves in watching the movements of
the emigrants, who now began their preparations
for their day's journey. By the time Uncle James
awoke, the trapper pronounced their breakfast
ready. After they had done ample justice to the
homely meal (and it was astonishing what an ap-
petite the fresh invigorating air of the prairie gave
them), the boys packed the cooking utensils away
in the wagon while the trapper began to harness
the mules. This was an undertaking that a less
experienced man would have found to be extremely
hazardous, for the animals persisted in keeping
their heels toward him, and it was only by skillful
maneuvering that Dick succeeded in getting them
hitched to the wagon. By the time this was ac-
complished, Uncle James and the boys had saddled
their horses and followed the trapper, who drove
off as though he perfectly understood what he was
about, leaving the train to follow at its leisure.

Dick acted as if he had again found himself
among friends from whom he had long been sepa-
rated; but it was evident that sorrow was mingled
with his joy, for on every side his eye rested on
the improvements of civilization. The road was
lined with fine, well-stocked farms, and the prairie

over which his father had hunted the buffalo and fought the Indian, had been turned up by the plow, and would soon be covered with waving crops. No doubt the trapper's thoughts wandered into the future, for, as the boys rode up beside the wagon, he said, with something like a sigh:

"Things aint as they used to be, youngsters. I can 'member the time when thar was 'nt a fence within miles of here, an' a feller could go out an' knock over a buffaler fur breakfast jest as easy as that farmer over thar could find one of his sheep. But the ax an' plow have made bad work with a fine country, the buffaler an' Injun have been pushed back t'wards the mountains, an' it won't be long afore thar 'll be no room fur sich as me; an' we won't be missed neither, 'cause when the buffaler an' beaver are gone thar 'll be nothin' fur us to do. These farms will keep pushin' out all the while; an' when folks, sittin' in their snug houses beside their warm fires, hear tell of the Injuns that onst owned this country, nobody will ever think that sich fellers as me an' Bill Lawson an' ole Bob Kelly ever lived. If ole Bill was here now, he would say: 'Let's go back to the mountains, Dick, an' stay thar.' He would n't like to see his

ole huntin' grounds wasted in this way, an' I do n't
want to see it neither. But I know that the Rocky
Mountains an' grizzly bars will last as long as I
shall, an' thar 'll be no need of trappers an' hunters
an' guides arter that."

Dick became silent after this, and it was not
until the train halted for the noon's rest, that he
recovered his usual spirits.

CHAPTER III.

Antelope Hunting.

RADUALLY the train left the improvements of civilization behind, and, at the end of three weeks, it was miles outside of a fence. Here the trapper was in his natural element. He felt, as he expressed, "like a young one jest out o' school," adding, that all he needed was "one glimpse of a Comanche or Cheyenne to make him feel perfectly nat'ral."

In accordance with the promise he had made Frank before leaving St. Joseph, he now took Pete (that was the name the latter had given his horse) under his especial charge; and every morning, at the first peep of day, the boys saw him galloping over the prairie, firing his rifle as fast as he could reload, as if in pursuit of an imaginary herd of

buffaloes. At first the spirited animal objected to
this mode of treatment, and made the most desper-
ate efforts to unseat his rider; but the trapper,
who had broken more than one wild mustang, was
perfectly at home on horseback, and, after a few
exercises of this kind, Pete was turned over to his
young master, with the assurance that he was ready
to begin buffalo hunting. According to Frank's
idea, the animal had improved considerably under
the trapper's system of training, for he would
hardly wait for his rider to be fairly in the saddle
before he would start off at the top of his speed.
The boys, who considered themselves fully able to
do any thing that had ever been accomplished by
any one else, having seen Dick load and fire his
rifle while riding at full speed, began to imitate his
example, and in a short time learned the art to
perfection. In addition to this, each boy looked
upon his horse as the better animal, and the emi-
grants were witnesses to many a race between
them, in which Sleepy Sam, as Archie called his
horse, always came off winner. But Frank kept
up the contest, and at every possible opportunity
the horses were "matched," until they had learned
their parts so well, that every time they found

themselves together, they would start off on a race without waiting for the word from their riders.

One morning, just after the train had left the camp, as the boys were riding beside the wagon, listening to a story the trapper was relating, the latter suddenly stopped, and, pointing toward a distant swell, said: "Do you see that ar', youngsters?"

The boys, after straining their eyes in vain, brought their field-glass into requisition, and finally discovered an object moving slowly along through the high grass; but the distance was so great, they could not determine what it was.

"That's a prong-horn," said the trapper at length. "An' now, Frank," he continued, "if you'll lend me that ar hoss, I'll show you that all the huntin' in the world aint larnt in that leetle patch of timber around Lawrence."

Frank at once dismounted, and Dick, after securing his rifle, sprung into the saddle, saying:

"Come along easy-like, youngsters, an' when I tell you, you get off an' hide behind your hoss."

Frank mounted Sleepy Sam behind Archie, and they followed the trapper, who led the way at an easy gallop. Useless, at his master's command,

remained with the wagon. They rode for a mile
at a steady pace, and then, seeing that the game
had discovered them, the boys, at a signal from the
trapper, stopped and dismounted, while Dick kept
on alone, his every movement closely watched by
Frank and Archie, who, having often read of the
skill required in hunting antelopes, were anxious
to see how it was done. The trapper rode on for
about half a mile further, and then the boys saw
him dismount, unbuckle the bridle, and hobble his
horse so that he would not stray away. He then
threw himself on his hands and knees, and disap-
peared. A quarter of an hour afterward the boys
saw his 'coon-skin cap waving above the grass. If
this was intended to attract the attention of the
game, it did not meet with immediate success, for
the antelopes continued to feed leisurely up the
swell, and finally some of their number disappeared
behind it. The boys regarded this as conclusive
evidence that the trapper's plan had failed; but at
length one of the antelopes, which stood a little
apart from the others, and appeared to be acting
as sentinel, uttered a loud snort, which instantly
brought every member of the herd to his side.
They remained huddled together for several mo-

ments, as if in consultation, and then began to move slowly down the swell toward the place where the trapper was concealed. There were about twenty animals in the herd, and they came on in single file, stopping now and then to snuff the air and examine the object that had excited their curiosity. But nothing suspicious was to be seen, for the trapper was concealed in the grass, the only thing visible being his cap, which he gently waved to and fro as he watched the movements of the game. The antelopes advanced slowly—much *too* slowly for the impatient boys, who, concealed behind their horse, closely watched all their movements, fearful that they might detect the presence of the trapper, and seek safety in flight. But the latter well understood the matter in hand, and presently the boys saw a puff of smoke rise from the grass, and the nearest of the antelopes, springing into the air, fell dead in his tracks. The others turned and fled with the speed of the wind.

In an instant Frank and Archie had mounted and when they reached the place where the trapper was standing, he had secured his prize, which was one of the most graceful animals the boys had ever seen. It was about three and a half feet

3

high at the shoulders, and, although Dick pro-
nounced it very fat, its body was slender and its
limbs small and muscular. After having exam-
ined the animal to their satisfaction, they all
mounted their horses, Dick carrying the game be-
fore him on his saddle; and as they rode toward
the wagon, Archie exclaimed:

"Now, Frank, we know how to hunt antelopes.
It isn't so very hard, after all."

"Isn't it?" inquired the trapper, with a laugh.
"You don't understand the natur of the critters,
when you say that. I know I killed this one easy
but a feller can't allers do it. Howsomever, you
can try your hand the next time we meet any, an'
if you do shoot one, I'll allers call you my 'ante-
lope killers.' Them red handkerchiefs of your'n
would be jest the things to use, 'cause the critters
can see it a long way. If you can bring one of
'em into camp, it will be something wuth braggin'
on."

It was evident that the trapper did not entertain
a very exalted opinion of the boys' "hunting quali-
ties;" but that did not convince them that they
could not shoot an antelope. On the contrary, it
made them all the more anxious for an opportu-

nity to try their skill on the game, if for no other reason than to show the trapper that he was mistaken.

Half an hour's riding brought them to the wagon, which was standing where they had left it, and, after the buck had been skinned and cleaned, the trapper mounted to his seat and drove after the train, followed by the boys, who strained their eyes in every direction in the hope of discovering another herd of antelopes. But nothing in the shape of a prong-horn was to be seen; and when the train resumed its journey after its noon halt, they gradually fell back until the wagons were out of sight behind the hills. Then, leaving the road, they galloped over the prairie until they reached the top of a high swell, when they stopped to look about them. About two miles to the left was the train slowly winding among the hills; but the most faithful use of their glass failed to reveal the wished-for game. All that afternoon they scoured the prairie on both sides of the wagons, and when it began to grow dark, they reluctantly turned their faces toward the camp.

"What did I tell you?" asked the trapper, as the boys rode up to the wagon, where the latter was

unharnessing the mules. "I said you could n't
shoot a prong-horn."

"Of course we could n't," answered Archie,
"for we did n't see any to shoot."

"I know that," replied the trapper with a grin;
"but *I* seed plenty. The next time you go a
huntin' prong-horns, be sartin that the wind blows
from them t'wards you, an' not from you t'wards
them. They've got sharp noses, them critters
have."

The boys were astonished. They had not thought
of that; and Archie was compelled to acknowledge
that "there was something in knowing how, after
all."

CHAPTER IV.

The Best Trapper on the Prairie.

HAT night the train encamped a short distance from one of the stations of the Overland Stage Company. The trapper, as usual, after taking care of his mules, superintended the preparations for supper, while the boys, wearied with their day's ride, threw themselves on the grass near the wagon, and watched his movements with a hungry eye. Uncle James, as he had done almost every night since leaving St. Joseph, walked about the camp playing with the children, who began to regard him as an old acquaintance. Presently the attention of the boys was attracted by the approach of a stranger, whose long beard and thin hair—both as white as snow—bore evidence to the fact that he carried the burden of many years on his shoulders.

He was dressed in a complete suit of buckskin, which, although well worn, was nevertheless very neat, and, in spite of his years, his step was firm, and he walked as erect as an Indian. He carried a long heavy rifle on his shoulder, and from his belt peeped the head of a small hatchet of peculiar shape, and the buck-horn handle of a hunting-knife. He walked slowly through the camp, and when he came opposite the boys, Dick suddenly sprang from the ground where he had been seated, watching some steaks that were broiling on the coals, and, striding up to the stranger, laid his hand on his shoulder. The latter turned, and, after regarding him sharply for a moment, thrust out his hand, which the trapper seized and wrung in silence. For an instant they stood looking at each other without speaking, and then Dick took the old man by the arm and led him up to the fire, exclaiming :

"Bob Kelly, the oldest an' best trapper on the prairy!"

The boys arose as he approached, and regarded him with curiosity. They had heard their guide speak in the highest terms of "ole Bob Kelly," and had often wished to see the trapper whom Dick was willing to acknowledge as his superior. There

he was—a mild, good-natured-looking old man, the exact opposite of what they had imagined him to be.

"Them are city chaps, Bob"—continued the trapper, as the old man, after gazing at the boys for a moment, seated himself on the ground beside the fire—"an' I'm takin' 'em out to Californy. In course they are green consarnin' prairy life, but they are made of good stuff, an' are 'bout the keerlessest youngsters you ever see. What a doin' here, Bob?"

"Jest lookin' round," was the answer. "I'm mighty glad to meet you ag'in, 'cause it looks nat'ral to see you 'bout. Things aint as they used to be. Me an' you are 'bout the oldest trappers agoin' now. The boys have gone one arter the other, an' thar's only me an' you left that I knows on."

"What's come on Jack Thomas?" asked Dick.

"We're both without our chums now," answered the old man, sorrowfully. "Jack an' ole Bill Lawson are both gone, an' their scalps are in a Comanche wigwam."

The trapper made no reply, but went on with his preparations for supper in silence, and the boys

could see that he was considerably affected by the news he had just heard. His every movement was closely watched by his companion, who seemed delighted to meet his old acquaintance once more, and acted as though he did not wish to allow him out of his sight. There was evidently a good deal of honest affection between these two men. It did not take the form of words, but would have showed itself had one or the other of them been in danger. They did not speak again until Mr. Winters came up, when Dick again introduced his friend as the "oldest an' best trapper agoin'." Uncle James, who understood the customs of the trappers, simply bowed—a greeting which the old man returned with one short, searching glance, as if he meant to read his very thoughts.

"Now, then!" exclaimed Dick, "Grub's ready. Pitch in, Bob."

The old trapper was not in the habit of standing upon ceremony, and, drawing his huge knife from his belt, he helped himself to a generous piece of the meat, and, declining the corn-bread and the cup of coffee which the boys passed over to him, made his meal entirely of venison. After supper—there were but few dishes to wash now, for the

boys had learned to go on the principle that "f.n-gers were made before forks"—the trapper hung what remained of the venison in the wagon, lighted his pipe, and stretched himself on the ground be-side his companion.

The boys, knowing that the trappers would be certain to talk over the events that had transpi. ed since their last meeting, spread their blankets where they could hear all that passed, and waited impa-tiently for them to begin; while Mr. Winters, who had by this time become acquainted with every man, woman, and child, in the train, started to pay a visit to the occupants of a neighboring wagon.

For some moments the two men smoked in si-lence, old Bob evidently occupied with his own thoughts, and Dick patiently waiting for him to speak. At length the old man asked:

"Goin' to Californy, Dick?"

The trapper replied in the affirmative.

"What a goin' to do arterward?"

"I'm a goin' to take to the mountains, an' stay thar," replied Dick. "I've seed the inside of a city, Bob; have rid on steam railroads an' boats as big as one of the Black Hills; an' now I'm satis-fied to stay here. I'd a heap sooner face a grizzly

or a Injun than go back thar ag'in, 'cause I lidn't feel to hum."

"Wal, I'm all alone now, Dick," said the old man, "an' so are you. Our chums are gone, an we both want to settle with them Comanche varmints; so, let's stick together."

Dick seemed delighted with this proposition, for he quickly arose from his blanket and extended his hand to his companion, who shook it heartily; and the boys read in their faces a determination to stand by each other to the last.

"I've got a chum now, youngsters," said Dick, turning to the boys; "an' one that I aint afraid to trust anywhar. Thar's nothin' like havin' a friend, even on the prairy. I come with the boys," he added, addressing his companion, who, seeing the interest Dick took in his "youngsters," slowly surveyed them from head to foot—"I come with 'em jest to show 'em how we do things on the prairy. They can shoot consid'ble sharp, an' aint afraid. All it wants is the hard knocks—fightin' Injuns an grizzlies, an' starvin' on the prairy, an' freezin' in the mountains, to make trappers of 'em." And here Dick settled back on his elbow, and proceeded to give the old man a short account of what had

transpired at Uncle Joe's cabin; described Frank's fight with the moose and panther in glowing language; told how the capture of the cubs had been effected, until old Bob began to be interested; and when Dick finished his story, he said:

"The youngsters would make good trappers."

This, as the trapper afterward told the boys, was a compliment old Bob seldom paid to any one, "for," said he, "I've knowed him a long time, an' have been in many a fight with him, an' he never told me I was good or bad."

"Wal," said Dick, again turning to his companion, "You said as how Jack Thomas was rubbed out. How did it happen?"

Old Bob refilled his pipe, smoked a few moments as if to bring the story fresh to his memory, and then answered:

"When I heered that Bill Lawson war gone, an' that you war left alone, I done my best to find you, an' get you to jine a small party we war makin' up to visit our ole huntin' grounds on the Saskatchewan; but you had tuk to the mountains, and nobody did n't know whar to go to find you. Thar war eight of us in the party, an' here, you see, are all that are left. As nigh as I can 'member, it war

'bout four year ago come spring that we sot out
from the fort, whar we had sold our furs. We had
three pack mules, plenty of powder, ball, an' sich
like, an' we started in high sperits, tellin' the tra-
der that bought our spelter that we'd have a fine
lot fur him ag'in next meetin' time. We knowed
thar war plenty of Injuns an' sich varmints to be
fit an' killed afore we come back, but that did n't
trouble us none, 'cause we all knowed our own bis-
ness, and did n't think but that we would come
through all right, jest as we had done a hundred
times afore. We did n't intend to stop afore we
got to the Saskatchewan; so we traveled purty fast,
an' in 'bout three weeks found ourselves in the
Blackfoot country, nigh the Missouri River. One
night we camped on a leetle stream at the foot of
the mountains, an' the next mornin', jest as we war
gettin' ready to start out ag'in, Jack Thomas—
who, like a youngster turned loose from school,
war allers runnin' round, pokin' his nose into what-
ever war goin' on—came gallopin' into camp,
shouting:

"'Buffaler! buffaler!'

"In course, we all knowed what that meant, an'
as we had n't tasted buffaler hump since leavin' the

fort, we saddled up in a hurry an' put arter the game. We went along kinder easy-like—Jack leadin' the way—until we come to the top of a swell, an' thar they war—nothin' but buffaler as fur as a feller could see. It war a purty sight, an' more 'n one of us made up our minds that we would have a good supper that night. We could n't get no nigher to 'em without bein' diskivered, so we scattered and galloped arter 'em. In course, the minit we showed ourselves they put off like the wind; but we war in easy shootin' distance, an' afore we got through with 'em, I had knocked over four big fellers an' wounded another. He war hurt so bad he could n't run; but I did n't like to go up too clost to him, so I rid off a leetle way, an' war loadin' up my rifle to give him a settler, when I heered a noise that made me prick up my ears an' look sharp. I heered a trampin, an' I knowed it war made by something 'sides a buffaler. Now, youngsters, a greenhorn would n't a seed any thing strange in that; but when I heered it, I did n't stop to kill the wounded buffaler, but turned my hoss an' made tracks. I had n't gone more 'n twenty rod afore I seed four Blackfoot Injuns comin' over a swell 'bout half a mile back. I had kept my

eyes open—as I allers do—but I had n't seen a bit
of Injun sign on the prairy, an' I made up my mind
to onct that them Blackfoot varmints had been
shyin' round arter the same buffaler we had jest
been chasin', an' that they did n't know we war
'bout till they heered us shoot. Then, in course,
they put arter us, 'cause they think a heap more
of scalps than they do of buffaler meat.

"Wal, as I war sayin', I made tracks sudden;
but they war n't long in diskiverin' me, an' they sot
up a yell. I 've heered that same yell often, an' I
have kinder got used to it; but I would have give
my hoss, an' this rifle, too, that I have carried for
goin' nigh onto twenty year, if I had been safe in
Fort Laramie, 'cause I did n't think them four In-
juns war alone. I war sartin they had friends not
a great way off, an' somehow I a'most knowed how
the hul thing was comin' out. I did n't hardly
know which way to go to find our fellers, 'cause
while we were arter the buffaler we had got scat-
tered a good deal; but jest as I come to the top
of a swell I seed 'em a comin'. Jack Thomas war
ahead, an' he war swingin' his rifle an yellin' wus-
ser nor any Injun. I 'll allow, Dick, that it made
me feel a heap easier when I seed them trappers.

Jack, who allers knowed what war goin' on in the
country fur five miles round, had first diskivered
the Injuns, an' had got all the party together 'cept
me, an' in course they could n't think of savin' their
own venison by runnin' off and leavin' me.

"Wal, jest as soon as we got together we sot up
a yell and faced 'bout. The Injuns, up to this
time, had rid clost together; but when they seed
that we war n't goin' to run no further jest then,
they scattered as if they war goin' to surround
us; an' then we all knowed that them four Injuns
war n't alone. So, without stoppin' to fight 'em, we
turned an' run ag'in, makin' tracks for the woods
at the foot of the mountains. An' we war n't a
minit too soon, fur all of a sudden we heered a
yell, an' lookin' back we seed 'bout fifty more red-
skins comin' arter us like mad. They had a'most
got us surrounded; but the way to the mountains
war open, an' we run fur our lives. The varlets
that had followed me war in good pluggin' distance,
an' when we turned in our saddles an' drawed a bead
on 'em, we had four less to deal with. It war n't
more 'n ten mile to the foot of them mountains, but
it seemed a hundred to us, an' we all drawed a
long breath when we found ourselves under kiver

of the woods. The minit we reached the timber we jumped off our hosses, hitched them to the trees, an' made up our minds to fight it out thar an' then. We knowed, as well as we wanted to know, what the Injuns would do next—they would leave a party on the prairy to watch us, an' the rest would go sneakin' round through the woods an' pick us off one at a time. The only thing we could do— leastwise till it come dark—war to watch the var- lets, an' drop every one of 'em that showed his painted face in pluggin' distance. We war in a tight place. Our pack mules, an' a'most all our kit, had been left in the camp, an' we knowed it would n't be long afore the Injuns would have 'em, an' even if we got off with our har, we would n't be much better off—no traps, no grub, an' skeercely half a dozen bullets in our pouches.

"Wal, the Injuns, when they seed that we had tuk to the timber, stopped, takin' mighty good keer, as they thought, to keep out of range of our rifles, an' began to hold a palaver, now an' then lookin' t'wards us an' settin' up a yell, which told us plain enough that they thought they had us ketched. But we, knowin' to an inch how fur our shootin' irons would carry, drawed up an' blazed away ; an'

we knowed, by the way them red-skins got back
ove: that swell, that we had n't throwed our lead
away. They left one feller thar to watch us, how-
somever, but he tuk mighty good keer to keep
purty well out of sight, showin' only 'bout two
inches of his head 'bove the top of the hill. While
the Injuns war holdin' their council, we had a talk
'bout what we had better do. The truth war, thar
war only one thing we could do, an' that war to
stay thar until dark an' then take our chances. We
had all fit savage Injuns enough to know that they
would n't bother us much so long as daylight lasted;
but arter that, if we did n't get away from thar, our
lives war not worth a charge of powder. We soon
made up our minds what we would do. We di-
vided ourselves into two parties—four of us watch-
in' the prairy, an' the others keepin' an eye on the
woods, to see that the varlets did n't slip up behind
us.

"Wal, we did n't see nothin' out of the way all
that day. Thar war that feller peepin' over the
hill, an' that war the only thing in the shape of a
red-skin we could see; an' we did n't hear nothin'
neither, fur whatever they done, they did n't make
noise enough to skeer a painter. At last it come
 4

night, an' it war 'bout the darkest night I ever see—
no moon, no stars—an' then we began to prick up
our ears. We all knowed that the time had come.
You can easy tell what we war passin' through our
minds. Thar war n't no sich thing as a coward
among us eight fellers, but men in sich a scrape as
that can't help thinkin', an' I knowed that every
one thar drawed a long breath when he thought of
what he had got to do. I tell you, Dick, it war
something none of us liked to do—leave one an-
other in that way—men that you have hunted, an'
trapped, an' fought Injuns with, an' mebbe slept
under the same blanket with, an' who have stuck
to you through thick an' thin—sich fellers, I say,
you do n't like to desart when they 're in danger.
But what else could we do? We war a'most out of
powder an' lead, an' the Injuns war more 'n six to
our one. You have been in sich scrapes, an' in course
know that thar war n't but one way open to us.

"Wal, as I was sayin', as soon as it come fairly
dark, the boys gathered 'round me, an' waited to
hear what I war goin' to do. In course, I could n't
advise 'em, 'cause it war every feller look out fur
himself, an' the best men war them as was lucky
enough to get away. So I said:

"'I'm goin' to start now, boys. It's high time we war movin', cause if we stay here half an hour longer, we'll have them red-skins down on us in a lump. Thar's somethin' goin' on, sartin. They don't keep so still fur nothin'.'

" Wal, we whispered the matter over, an' finally settled it. The oldest man war to go fust; the next oldest, second; an' so on; an' that them as got away should draw a bee-line fur Fort Laramie, an' get thar to onct, so that we might know who got off an' who didn't. We didn't think we should all get away. Some war sartin to go under; an', Dick, we didn't forget to promise each other that those of us that lived would never let a red Injun cross our trail. When every thing was settled, I, bein' the oldest man in the comp'ny, began to get ready fur the start. I put fresh primin' in my rifle; seed that my knife and tomahawk war all right; then, arter shakin' hands with all the boys, an' wishin' 'em good luck, I crawled away on my hands an' knees. I didn't go back into the woods, but tuk to the edge of the prairy, an' found the way cl'ar. Not an Injun did I hear. As fur seein', you couldn't a told your mother, if she warn't two foot from you; an' in 'bout half an hour I found my-

self on the banks of a leetle creek. How long I
lay thar, an' how much of that water I drunk, I
do n't know; but I thought water never tasted so
good afore. Then I walked into the creek, an' had
waded in it fur 'bout half a mile, when all to onct I
heered a yellin' an' whoopin', followed by the crack
of rifles, an' then I knowed that I had n't been
fooled consarnin' what the red-skins meant to do.
They had got what war left of our fellers surround-
ed, an' made the rush. Fur a minit I stood thar
in the water an' listened. I heered a few shots
made by our poor fellers, 'cause I can tell the crack
of a Missouri rifle as fur as I can hear it; an' then
one long, loud yell, told me that it war all over.

"Wal, I laid round in them mountains fur
more 'n six weeks, starvin' fur grub an' water, an'
listenin' to the yellin' varlets that war huntin arter
me; but I got back safe at last, arter walkin' all
the way from the Rocky Mountains to the fort, an'
thar I found Jack Thomas. Me an' him war the
only ones that got out. When the Injuns got them
six fellers, they rubbed out nearly the last one of
our comp'ny. Me an' Jack war mighty down-
hearted 'bout it, an' it war a long time afore we
could b lieve that we war left alone. We did n't

feel then like ever goin' oack to the mountains
ag'in, 'cause we knowed it would be lonesome thar.
In course, we could easy have made up another ex-
pedition, fur thar war plenty of hunters an' trap-
pers—good ones, too—hangin' round the fort; but
somehow we did n't feel like goin' off with any one
outside of our own comp'ny.

"Wal, me an' Jack laid round as long as we
could stand it, an' then we got a couple of hosses,
another new kit, an' sot off ag'in. We did n't think
it safe fur only two of us to try the Blackfoot
country ag'in, so we struck for the huntin' grounds
on the Colorado. At that time thar war plenty of
beaver in that river; so it did n't take us long to
find a place that suited us; an' we settled down,
comfortable-like, to spend the winter. Fur three
months we had plenty of sport, an' the sight of our
pile of furs, growin' bigger an' bigger every day,
made us happy an' contented. One mornin' we sot
out bright an' 'arly, as usual, to 'tend to our bis-
ness, takin' different directions—fur my traps war
sot on the side of the mountain, an' Jack had sot
his 'ne on the banks of the creek that run through
the valley. I had been gone frum him but a short
time, when I heered the crack of his rifle. Some-

how, I knowed it war somethin' 'sides a varmint he had shot at; an' I war n't fooled neither, for a minit arterward I heered another gun, an' then afore I could think twice a Comanche yell come echoin' from the valley, tellin' me plainer nor words that my chum war gone. An Injun had watched one of his traps, an' shot him as he come to it. I knowed it as sartin as if I had seed the hul thing done.

"Wal, I war n't in a fix kalkerlated to make a feller feel very pleasant. I war three hundred miles from the nighest fort, in the very heart of the Comanche country, an' in the dead of winter, with the snow two foot deep on a level. But I did n't stop to think of them things then. My bisness war to get away from thar to onct. In course, I could n't go back arter my hoss or spelter, fur I did n't know how many Injuns thar war in the valley, nor whar they had hid themselves; so I shouldered my rifle an' sot off on foot t'wards the prairy. A storm that come up that night—an' it snowed an' blowed in a way that war n't a funny thing to look at—kivered up my trail; an' if I war ever follered, I do n't know it.

"I finally reached the fort, an' I 've been thar ever

since. I'm an ole chap now, Dick; but when I
hunted an' trapped with your ole man, when me an'
him warn't bigger nor them two youngsters, an'
hadn't hardly strength enough to shoulder a rifle,
I never thought that I should live to be the last of
our comp'ny. In them days the prairy war differ-
ent from what it is now. It war afore the hoss-
thieves an' rascals began to come in here to get
away from the laws of the States; an' them that
called themselves trappers then war honest men,
that never did harm to a lone person on the prairy.
But they've gone, one arter the other, an' only me
an' you are left."

As the old trapper ceased speaking, he arose
suddenly to his feet and disappeared in the dark-
ness, leaving Dick gazing thoughtfully into the
fire. It was an hour before he returned, mounted
on his horse, which he picketed with the others.
He then silently rolled himself up in his blanket
and went to sleep.

Bob·Kelly

CHAPTER V.

A Fight with the Indians.

HEN setting out the next morning, Frank noticed that the wagons, instead of starting off singly, and straggling, as they had formerly done, kept close together, and traveled more rapidly. The trapper, too, instead of taking the lead, and getting in advance of the train, seemed satisfied to remain with the others. Upon inquiring the reason for this, Dick replied:

"You may find out afore night, youngster, that we are in a bad bit of Injun country. The train that went out afore us had a scrimmage here with nigh five hundred of the red-skins, who stampeded some of their stock. So keep your eyes open, an' if you see a Injun, let me know to onct." The trapper said this with a broad grin, that was meant

to imply that if they were attacked, the Indians would make their appearance before a person so inexperienced as Frank could be aware of it.

"The red-skins do n't gener'lly keer 'bout an out-an'-out fight," continued the trapper, "'cause they do n't like these long rifles, an' they know that these yere pioneers shoot mighty sharp. All the Injuns want—or all they can get—is the stock; an' they sometimes jump on to a train afore a feller knows it, an' yell an' kick up a big fuss, which frightens the cattle. That 's what we call stampedin' 'em. An', youngster, do you see that 'ar?"

As the trapper spoke, he pointed out over the prairie towards a little hill about two miles distant. After gazing for a few moments in the direction indicated, Archie replied:

"I see something that looks like a weed or a tuft of grass."

"Wal, that 's no weed," said the trapper, with a laugh, "nor grass, neither. If it is, it 's on hossback, an' carries a shootin'-iron or a bow an' arrer. That 's a Injun, or I never seed one afore. What do you say, Bob?" he asked, turning to the old trapper, who at this moment came up.

"I seed that five minutes ago," was the reply, "an' in course it can't be nothin' but a red-skin."

The boys gazed long and earnestly at the object, but their eyes were not as sharp as those of the trappers, for they could not discover that it bore any resemblance to an Indian, until Mr. Winters handed them his field-glass through which he had been regarding the object ever since its discovery. Then they found that the trappers had not been deceived. It was a solitary Indian, who sat on his horse as motionless as a statue, no doubt watching the train, and endeavoring to satisfy himself of the number of men there might be to defend it. In his hand he carried something that looked like a spear adorned with a tuft of feathers.

"I wish the varlet was in good pluggin' distance," said Dick, patting his rifle which lay across his knees. "If I could only get a bead on him, he would never carry back to his fellers the news of what he has seed."

"Do you suppose there are more of them?" asked Archie, in a voice that would tremble in spite of himself.

"Sartin," replied old Bob Kelly, who still rode beside the wagon; "thar's more of 'em not fur

off. This feller is a kind o' spy like, an' when he has seen exactly how things stand, he 'll go back an' tell the rest of 'em, an' the fust thing we know, they 'll be down on us like a hawk on a June-bug. But they 'll ketch a weasel, *they* will, when they pitch into us. Dick, when they do come, do n't forget Bill Lawson."

The trapper turned his head, for a moment, as if to hide the emotion he felt, at the mention of the name of his departed companion, but presently replied :

" This aint the fust time that you an' me have been in jest sich scrapes, Bob, an' it aint likely that we 'll soon forget that we owe the varlets a long settlement. Thar aint as many of us now as thar used to be; more 'n one good trapper has had his har raised by them same red-skins—fur I know a Cheyenne as fur as I kin see him, young-sters—an' mebbe one o' these days, when some one asks, 'What 's come on ole Bob Kelly an' Dick Lewis ?' the answer will be, 'Killed by the Injuns !' "

It may be readily supposed that such conversa-tion as this was not calculated to quiet the feel-ings of Frank and Archie—who had been consid-

erably agitated by the information that there was a
body of hostile Indians at no great distance—and
to their excited imaginations the danger appeared
tenfold worse than it really was. At that day,
as the trapper had remarked, it was a very uncom-
mon occurrence for a large train to be engaged in
a regular fight with the Indians, for the latter had
learned to their cost that the pioneers were always
well armed, and that there were some among them
who understood Indian fighting. They generally
contented themselves with sudden and rapid raids
upon the stock of the emigrants, and they seldom
departed empty-handed. But it is not to be won-
dered that the trappers, who had participated in
numberless engagements with the savages, and
witnessed deeds of cruelty that had awakened in
them a desire for vengeance, should delight to talk
over their experience. The boys, although consid-
erably frightened, were still greatly encouraged by
their example. Dick twisted uneasily on his seat,
as though impatient for the fight to begin, now
and then looking toward the spy, as if he had
half a mind to venture a shot at him; while old
Bob Kelly rode along, smoking his pipe, appar-
ently as unconcerned as though there was not a

hostile Indian within a hundred miles of them.
Mr. Winters evidently partook of the old man's
indifference, for, after satisfying himself that his
weapons were in readiness, he drew back beside
his nephews, and said, with a smile:

"Well, boys, you may have an opportunity to
try your skill on big game now. This will be a
little different from the fight you had in the woods
with those Indians who stole your traps. Then
you had the force on your side; now the savages
are the stronger party. But there's no danger,"
he added, quickly seeing that the boys looked
rather anxious; "every man in the train is a good
shot, and the most of them have been in Indian
fights before. I do n't believe all the red-skins on
the prairie could whip us while we have Dick and
Bob with us."

The boys themselves had great confidence in the
trappers—especially Dick, who, they knew, would
never desert them. But even *he* had several times
been worsted by the Indians. Frank thought of
the story of the lost wagon train. But then he re-
membered that the reason that train was captured,
was because the emigrants had not "stood up to
the mark like men."

All this while the train had been moving ahead
at a rapid pace, and many an anxious eye was di-
rected toward the solitary Indian, who remained
standing where he was first discovered until the
wagons had passed, when he suddenly and myste-
riously disappeared. All that day the emigrants
rode with their weapons in their hands, in readiness
to repel an attack; and when they halted at noon,
guards were posted about the camp, and the cattle
were kept close to the wagons. But, although now
and then a single Indian would be seen upon one
of the distant swells, the main body kept out of
sight; and the boys began to hope that the train
was considered too large to be successfully at-
tacked. At night old Bob Kelly selected the
place for the encampment, which was made accord-
ing to his directions. The wagons were drawn up
in a circle to form a breastwork, and the cattle
were picketed close by under the protection of a
strong guard. Fires were built, and preparations
for supper carried on as usual, for, of course, all
attempts at concealment would have been time and
labor thrown away. As soon as it began to grow
dark, the cattle were secured to the wagons by
long stout ropes, which, while they allowed the

animals to graze, effectually prevented escape. Then guards were selected, and the emigrants made every preparation to give the savages a warm reception, in case they should make a dash upon the camp. No one thought of his blanket. The idea of going to sleep while a band of Indians was hovering about, watching their opportunity to pounce down upon them, was out of the question. The two trappers, after satisfying themselves that every thing was in readiness for an attack, began to station the guards. Frank again thought of the story Dick had related of the lost wagon train, and, desiring to witness an exhibition of the skill that had enabled him to detect the presence of the Indians on that occasion, proposed to Archie that they should stand guard with him. The latter, who always felt safe when in the company of their guide, agreed; and when the trapper started off with the guards, he was surprised to find the boys at his side.

"Whar are you goin'?" he asked.

"We want to stand guard with you!" replied Frank.

"Wal, I never *did* see sich keerless fellers as you be," said the trapper. "You get wusser an'

wusser. Much you do n't know about this bisness
I guess you had better stay here whar you 're
safe."

"Wal, wal!" said old Bob Kelly, who was not a
little astonished at the request the boys had made,
"they 've got the real grit in 'em, that 's a fact,
if they are green as punkins in Injun fightin'. A
few year on the prairy would make 'em as good as
me or you, Dick Lewis. But you 'll get enough
of Injuns afore you see daylight ag'in, youngsters.
So you had better stay here."

So saying he shouldered his rifle, and, followed
by the guards, disappeared in the darkness. The
boys reluctantly returned to their wagon, where
they found Uncle James, seated on the ground,
whistling softly to himself, and apparently indiffer-
ent as to the course the Indians might see fit to
adopt. But still he had not neglected to make
preparations to receive them, for his rifle stood
leaning against one of the wheels of the wagon,
and he carried his revolvers in his belt. The boys
silently seated themselves on the ground beside
him, and awaited the issue of events with their
feelings worked up to the highest pitch of excite-
ment. The fires had burned low, but still there

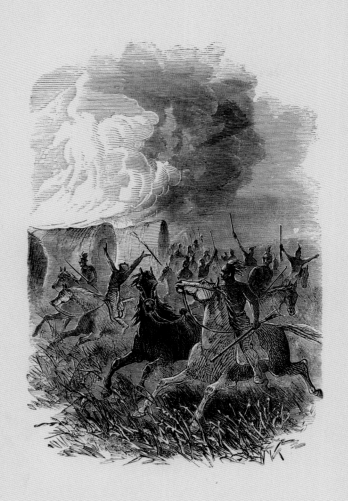

was light sufficient to enable them to discover the emigrants stretched on the ground about the wagons, talking to one another in whispers, as if almost afraid to break the stillness that brooded over the camp, and which was interrupted only by the barking of the prairie wolves, and the neighing and tramping of the horses. Two hours were passed in this way, when suddenly the sharp report of a rifle, accompanied by a terrific yell, rang out on the air, causing the emigrants to grasp their weapons and spring to their feet in alarm. For an instant all was silent again. The stillness was so deep that Frank thought the camp was suddenly deserted. Then a long drawn out whoop arose from the prairie, followed by a chorus of yells that struck terror to more than one heart in that wagon train. Then came a clatter of horses' hoofs; the yells grew louder and louder; and the boys knew that the Indians were coming toward them. The emigrants rushed to the wagons, and the next moment the savages swept by. The boys saw a confused mass of rapidly-moving horsemen; heard the most terrific yells, the report of fire-arms, and the struggles of the frightened cattle as they attempted to escape, and then all was over. The Indians de-

5

parted as rapidly as they had come, and the boys, bewildered by the noise, had not fired a shot. On the contrary, they stood holding their rifles in their hands, as if they had suddenly forgotten how to use them. Uncle James, however, was not confused. He had heard the war-whoop before, and as he came out from behind the wagon, he began to reload one of his revolvers, remarking as he did so:

"There are some less in that band, I know."

"Did you shoot?" asked Archie, drawing a long breath of relief to know that the danger was past. "Why, I did n't have time to fire a shot."

"That's because you were frightened," replied Mr. Winters. "You see I have been in skirmishes like this before, and their yells do n't make me nervous. I had five good shots at them, and I do n't often miss."

"I say, youngsters, are you all right?" exclaimed Dick, who at this moment came up. "See here! I've got two fellers' top-knots. Bless you, they aint scalps," he continued, as the boys drew back. "They're only the feathers the Injuns wear in their har. I do n't scalp Cheyennes, 'cause I do n't keer 'bout 'em. I make war on 'em 'cause it 's natur. But when I knock over a Co-

manche, I take his har jest to 'member ole Bill by. But, youngsters, warn't that jolly! I haven't heered a Injun yell fur more'n a year, an it makes me feel to hum. You can take these feathers, an' when you get back to Lawrence, tell the folks thar that the Injuns that wore 'em onct attacked the train you belonged to."

The emigrants' first care, after having satisfied themselves that the Indians had gone, was to count their stock; and more than one had to mourn the loss of a favorite horse or mule, which had escaped and gone off with the Indians. Mr. Winters, however, had lost nothing—the trapper having tied the animals so securely that escape was impossible. Not a person in the train was injured—the only damage sustained being in the canvas covers of the wagons, which were riddled with bullets and arrows.

The boys were still far from feeling safe, and probably would not have gone to bed that night had they not seen the trappers spreading their blankets near the wagon. This re-assured them, for those men never would have thought of rest if there had been the least probability that the Indians would return. So the boys took their beds out

of the wagon and placed them beside those of Dick and his companion, who were talking over the events of the night.

"This bisness of fightin' Injuns, youngsters," said the former, "is one that aint larnt out of books, nor in the woods about Lawrence. If you had a-been with us, you would a seed that. Now, when I fust went out thar, you could n't 'a' told that thar war a red-skin on the prairy. But I laid my ear to the ground, an' purty quick I heerd a rumblin' like, an' I knowed the noise war made by hosses. Arter that, I heerd a rustlin' in the grass, an' seed a Injun sneakin' along, easy like, t'wards the camp. So I drawed up my ole shootin' iron, an' done the bisness fur him, an' then started fur the camp, loadin' my rifle as I ran. In course the Injuns seed then that it war n't no use to go a-foolin' with us, so they all set up a yell, an' here they come. I dodged under the wagon, an' as they went by, I give 'em another shot, an' seed a red-skin go off dead."

"Go off dead!" repeated Frank. "How could he go off when he was dead?"

"Why," said the trapper, with a laugh, in which he was joined by old Bob Kelly, "every one of

them Injuns war tied fast to his hoss, so that if he war killed he would n't fall off; an', in course, his hoss would keep on with the rest, an' carry him away. I seed more 'n one Injun go off dead to-night, an' the way I come to get them feathers, b'longin' to them two chaps, war, that somebody had shot their hosses. I seed 'em on the ground, tryin' to cut themselves loose from their saddles, so I run up an' settled 'em. That war four I rubbed out. Good-night, youngsters. You need n't be afraid, 'cause they won't come back again to-night."

As the trapper spoke, he placed his cap under his head for a pillow, re-arranged his blanket, and was soon in a sound sleep.

During the next two weeks nothing occurred to relieve the monotony of the journey. The train took up its line of march at daylight, halted at noon for an hour or two, and shortly after sunset encamped for the night. The fight with the Indians had not driven all thoughts of the antelopes out of the boys' minds. And while the train journeyed along the road, they scoured the prairie, in search of the wished-for game. The appearance of the "sea of grass," which stretched away on all sides,

as far as their eyes could reach, not a little surprised
them. Instead of the perfectly level plain they had
expected to see, the surface of the prairie was
broken by gentle swells, like immense waves of the
ocean, and here and there—sometimes two or three
days' journey apart—were small patches of woods,
called "oak openings."

One night they made their camp in sight of
the Rocky Mountains. While the trapper was
cooking their supper, he said to the boys, who
had thrown themselves on the ground near the
wagon:

"It aint fur from here that me an' ole Bill Law-
son lost that wagon train. I never travel along
here that I do n't think of that night, an' I some-
times feel my cap rise on my head, jest as it did
when them Injuns come pourin' into the camp.
But the varlets have been pushed back further an'
further, an' now a feller's as safe here as he would
be in Fort Laramie. The ole bar's hole aint
more 'n fifty mile from here, an' if your uncle
do n't mind the ride, I should like to show you the
cave that has so often sarved me fur a hidin'-
place."

The boys looked toward Mr. Winters, who, hav-

ing frequently heard the guide speak of the "ole
bar's hole," felt some curiosity to see it. So, af-
ter being assured by both the trappers that there
was no danger to be apprehended, he gave his con-
sent, remarking:

"We are in no hurry. I don't suppose there
is any possibility of being lost so long as we have
Dick and Bob for guides; so we will go there, and
take a week's rest and a hunt."

The boys were delighted, and the next morning,
when the train resumed its journey, the emigrants
were not a little surprised to see Mr. Winters'
wagon moving off by itself.

That night, when our travelers encamped, they
were thirty miles from the train, and about the
same distance from the "ole bar's hole." The
mountains were plainly visible, and the boys could
scarcely believe that they were nearly a day's
journey distant. They were certain that a ride
of an hour or two would bring them to the willows
that skirted their base.

" 'T aint the fust time I've seed fellers fooled
'bout sich things," said Dick. "Do you see that
'ar high peak?" he continued, pointing to a single
mountain that rose high above the others. "Wal,

thar's whar the ole bar's hole is. If we reach it
afore dark to-morrer night, I 'll agree to set you
down in Sacramento in two weeks."

The boys were still far from being convinced,
and they went to sleep that night fully believing
that they would reach the mountains by noon the
next day.

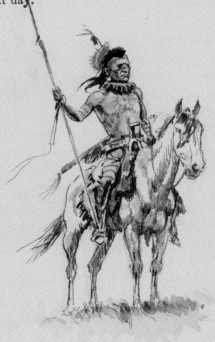

CHAPTER VI.

Lost on the Prairie.

HE next morning, by the time the sun had risen, the travelers had eaten their breakfast, and were again on the move. The entire party was in high spirits The trappers laughed and joked with each other, and pointed out to Mr. Winters the familiar objects that met their eye on every side, while the boys galloped on before, and in a few moments had left the wagon far behind. Their horses were in excellent trim, and bounded along over the prairie as if some of their riders' spirits had been infused into them.

"I say, Frank," said Archie, at length, suddenly drawing in his rein, "what if Dick was mistaken about the Indians all being gone, and a party of Comanches should suddenly pounce down on us? Wouldn't we be in a fix? I declare, I see an In-

dian now," he added; and, as he spoke, he pointed toward an object that could be dimly seen moving along the summit of a distant swell.

"That's something, that's a fact," said Frank, gazing in the direction indicated; "but it don't look like that Indian we saw the other day. If it was a Comanche, he wouldn't move about and show himself so plainly. There's another—and another," he continued, as several more objects came over the brow of the hill. "Let us ride up a little nearer. If they are Indians, we can easily reach the wagon before they can overtake us."

"Well, come on," said Archie. "If we should get into a fight all by ourselves, and come safely out of it, it would be something to talk about, wouldn't it?"

The boys rode cautiously toward the objects, which were still increasing in number, holding themselves in readiness to beat a hasty retreat in case they should prove to be Indians, until they had gone about half a mile, when Frank suddenly exclaimed:

"They are antelopes!"

"Are they?" asked Archie, excitedly. "Let's shoot one of 'em," and, springing from his saddle,

he began to unbuckle his halter and hobble his horse, as he had seen the trapper do on a former occasion.

Frank followed his example, and then, securing their rifles, they threw themselves on their hands and knees, and began to crawl toward the game, which was fully a mile and a half distant. But that was no obstacle to the boys then. They would willingly have gone twice that far to have a shot at an antelope, if for nothing more than to show the trapper that they were better hunters than he had supposed. It is true they did not expect to succeed, but the name "antelope killers" was well worth trying for, and they determined to do their best. They crawled along slowly and as carefully as possible, pausing now and then to look over the grass at the animals, which, to their delight, they found were feeding directly toward them.

"I don't think it is safe to go much further," said Frank, after they had crawled nearly half the distance in this manner. "Let's stop and see what we can do."

"Well," said Archie. "If you will hold up your handkerchief on your ramrod, I'll try and shoot one of them, if they come near enough."

Frank, in compliance with his cousin's sugges-
tion, drew his ramrod from his gun, fastened his
handkerchief to it, and, throwing himself upon his
back, carefully raised it above the grass. While
in this position he could not, of course, see the
movements of the game; but Archie kept vigilant
watch, and at length whispered:

"They see it! They're coming!"

The animals had, in reality, caught sight of the
handkerchief, and, after regarding it for a few mo-
ments, they began to approach it—a fine large
buck leading the way.

Now the boys knew that the hunt began in earnest.
The least awkward movement on their part—the
exposure of the smallest portion of their bodies, or
the slightest noise in the grass—might, as Archie
expressed it, "knock the whole thing in the head."
Frank lay perfectly quiet, watching the movements
of his cousin; and he could tell, by the expression
of his countenance, pretty near what the game was
doing. When the antelopes stopped—which they
did every few feet—Archie put on an exceedingly
long face, as if fearful that they were about to turn
and run; and when they approached, the fact
would be indicated by a broad grin and a nervous

twitching at the lock of his gun. For fully half an hour—it seemed much longer to the impatient boys—they remained in their place of concealment; but at length their patience was rewarded, for the game was within easy rifle range. In an instant Archie's nervousness all vanished, and Frank almost held his breath when he saw him slowly, inch by inch, raise his gun to his shoulder. He took a long, steady aim, pulled the trigger, and sprung from the ground, shouting:

"I've got him! I've got him!"

Frank was on his feet almost as soon as his cousin, and, to his delight, saw the leader of the antelopes struggling on the ground, while the rest of the herd were scampering away at the top of their speed.

"What will Dick and Bob say now?" exclaimed Archie, who skipped about as though he were almost beside himself. "What will they—hold on— hold on—shoot him, Frank!" he shouted. "We're going to lose him after all."

Archie's shot had not been fatal. The buck was only disabled for a moment, and, after a few struggles, he succeeded in regaining his feet, and started to run. Had his cousin been as excited as he was,

they certainly would have had all their trouble for nothing, for Archie, instead of stopping to reload, dropped his gun and started in pursuit of the wounded animal, which—although he ran but slowly—was fast leaving him behind, when Frank, by an excellent shot, again brought him to the ground. This time the wound was fatal; but Archie, to put all further attempts at escape out of the question, ran up and seized the buck by the horns.

"He's done for now," said Frank, as he proceeded to reload his rifle; "I shot him through the head."

"I see you did," replied his cousin, still retaining his hold upon the antelope; "but there's no knowing what he might do. I would n't trust him." And it was not until he had turned the deer over several times, and fully satisfied himself that he had ceased to breathe, that Archie released him.

"What will Dick and Bob say now?" he continued, as Frank came up, and they began to examine their prize, which was much larger than the one the trapper had killed. "You know they said we could n't shoot an antelope. Now, the next

thing is to get him back to the wagon. He's too heavy for us to carry, so if you'll stay here, and watch him and keep the wolves off, I'll go back and get the horses."

Frank agreed to this arrangement, and Archie, after he had found and reloaded his gun, started off after the horses. He was gone almost two hours—so long that Frank began to be uneasy; but at length he appeared, riding post-haste over a neighboring swell, mounted on Sleepy Sam, and leading Pete by the bridle. As soon as he came within speaking distance, he exclaimed, with blanched cheeks:

"Frank, we're lost! I can't see the wagon any where."

"Don't be uneasy," replied his cousin, who, although thoroughly alarmed by this announcement, appeared to be perfectly unconcerned. "Don't be uneasy."

"But I have n't seen the wagon since we left it this morning," persisted Archie. "I thought it was close behind us. I tell you we're lost."

"Oh no, I guess not," answered Frank, as he lifted the antelope from the ground and placed it on the saddle before his cousin. "The wagon is

no doubt behind some of these hills. Besides, Uncle James won't be long in hunting us up."

"I wouldn't stay alone on the prairie to-night for any thing," said Archie. "I know it wouldn't be the first time I have camped out, but then there are no wild Indians in the woods about Lawrence."

Frank had by this time mounted his horse, and together they set out at a rapid gallop to find the wagon. The mountain which Dick had pointed out the night before was plainly visible, and the boys determined to travel toward it with all possible speed, in hopes that they would overtake their friends before they halted for the night. Frank thought the wagon could not be far off, and every hill they mounted he gazed about him as if fully expecting to discover it; but, after riding an hour without seeing any signs of it, he began to be a good deal of his cousin's opinion, that they were lost. But he made no remark, for he knew that a good deal depended upon keeping up Archie's courage.

"We have not been gone from the wagon three hours," said he, "and they haven't had time to get very far away from us. We'll find them be-

hind some of these swells. Perhaps we 'll be in time to give them a piece of our antelope for dinner."

Archie made no reply, for he derived no encouragement from this; but he silently followed his cousin, who led the way at a rapid gallop, riding over this swell, and turning round that, as though he was perfectly familiar with the ground over which they were traveling. For two long hours they kept on in this way, almost without speaking, each time they mounted a hill straining their eyes in every direction, in the hope of discovering the wagon. Sometimes they were almost certain they saw its white cover in the distance; but upon taking a second look, it proved to have been merely a creation of their imagination; and Frank began to be discouraged. To add to their discomfort, the heat was almost intolerable, and they began to be tortured with thirst. Their animals also appeared to be suffering, for they paid less attention to the spur, and were constantly jerking at the reins, and endeavoring to go in a direction almost contrary to that which the boys desired. The hours seemed lengthened into ages, and at three o'clock in the afternoon they had

6

seen no signs of the wagon, and the mountains appeared to be as far off as ever.

"There's no use talking," said Archie, at length, reining in his horse, "I can't stand this any longer, I'm so thirsty."

"But what else can we do?" asked Frank, in a husky voice, for his tongue was so parched that he could scarcely talk plainly. "We can't find our friends, or water either, by staying here. We *must* go on."

As he spoke, he again spurred his horse into a gallop, Archie, as before, following after him, now and then looking down at the antelope, which lay across his saddle—and which he considered to be the cause of all their trouble—as though he heartily wished him safe among the others of the herd. Two miles more were passed, but still no signs of water. The idea of finding the wagon had now given away to a desire to discover some stream where they might quench their thirst, which was becoming almost unbearable. But the dry, parched prairie stretched away on each side of them, while in front loomed the mountains, apparently as distant as when they started in the morning. Their horses grew more and more restive.

Upon applying the spur, they would gallop for a few yards, and then settle down into a slow walk, turning their heads and pulling at the reins as if anxious to go in a contrary direction. This set Frank to thinking. He had often read of the remarkable sagacity sometimes displayed by the horse—how the animal had been known to carry his lost rider safely into the midst of his friends—and, turning to his cousin, he exclaimed:

"Archie, I'm going to let Pete take his own course. Both the horses want to go back, so let's see where they will take us to. We can't be in a much worse fix than we are now."

As he spoke, he threw the reins on his horse's neck, and the animal, finding himself at liberty, at once turned, and, pricking up his ears, galloped off exactly at right angles with the course they had been pursuing. Archie, too dispirited to raise any objections, followed his cousin's example, and the old buffalo hunter, which, during the last two hours, had traveled with his head down, as if scarcely able to take another step, snuffed the air and bounded off at a rapid pace. For an hour the animals tore along at a tremendous rate; but discovering no signs of the wagon, Frank was rapidly

losing faith in the sagacity of his horse, when, as
they came suddenly around the base of a swell,
they found before them a long line of willows.
Toward this the animals made their way with in-
creased speed, carrying their riders through the
trees into a stream of clear, running water.

CHAPTER VII.

The Trapper's Reminiscence.

HE horses did not stop on the bank, but, in spite of the desperate efforts of the boys, kept on, until the water reached half way to their backs. The old buffalo hunter, not satisfied with this, persisted in lying down; and Archie and the antelope were deposited in the middle of the stream. Under any other circumstances, the young hunter would have been angry; but, as it was, the cool bath was most refreshing after his long ride over the dry prairie, under the hot, scorching sun; so seizing the antelope, he dragged him to the shore, leaving his horse to take care of himself.

Thirsty as the boys were, they still retained their presence of mind; instead of endangering his life by drinking freely of the water, Archie

contented himself with repeatedly bathing his head, while Frank, who was still in his saddle, reached down and scooped up a few drops in his hand.

"I say, Frank, is n't this glorious?" said Archie at length, as he divested himself of his coat, which he hung upon a limb to dry. "But it 's lucky that my ammunition is water-proof. If you had been in my fix, you would n't be able to do much more shooting until we got back to our wagon. I declare, it 's getting dark. Where do you suppose that wagon is? If we do n't find it inside of fifteen minutes, we shall have to camp."

"Let 's stay here," said Frank, as he rode his horse out of the water, and fastened him to a tree. "We must stay somewhere all night, and this is as good a camping-ground as we can find."

"If Dick or Bob was here," said Archie, "I would n't mind it; but I do n't like the idea of our staying here alone. This is the worst scrape I was ever in; but if I once get along-side of that wagon again, I 'll stay there."

"Oh, you 've been in worse scrapes than this," said Frank, who saw that his cousin was losing heart again.

"I'd like to know when and where?" said Archie, looking up in astonishment.

"Why, you were in a much more dangerous situation while you were hanging by that limb, fifty feet from the ground, when you were after that 'coon that led you such a long chase."

"I can't see it," replied Archie. "I knew that if I got down safe, I would be among friends, and if I had to camp in the woods there would be no Comanches or grizzly bears waiting for a chance to jump down on me. I say, Frank, there *may* be grizzly bears about here," and Archie peered through the trees, reaching rather hurriedly for his gun, as if fully expecting to see one of those ferocious animals advancing upon him. "But what are you about?" he continued, as he saw Frank removing the saddle from his horse.

"I'm getting ready to camp," replied Frank, coolly.

Archie at first strongly objected to this, but Frank finally carried the day, by assuring him that it was the much better plan to "take matters easy," and wait for daylight, when they would again set out. Besides, if they traveled in the dark, they might go miles out of their way. Archie, although not con-

vinced, finally agreed to his cousin's proposition,
remarking :

"If you were in the fourth story of a burning
house, I wonder if you would n't talk of taking
matters easy ?"

It was settled then that they should remain where
they were for the night, and they began to make
preparations accordingly. Archie's horse was re-
lieved of the saddle, and, after both the animals
had been led on to the prairie, they were hobbled
and left to graze. Frank then began to skin and
dress the buck, while Archie gathered a supply of
wood, and kindled a fire. In half an hour several
slices of venison were broiling on the coals, and the
boys were lying before the fire, talking over the
events of the day, and wondering what Dick and
Bob would say when they learned that their
"youngsters" had killed an antelope, when they
were startled by a well-known bark, and the next
moment Useless came bounding through the trees
into the very center of the camp, where he frisked
and jumped about with every demonstration of joy.
The boys had scarcely recovered from their alarm,
when they heard a familiar voice exclaim :

"Bar an' buffaler ! You keerless fellers !" and

the trapper came through the willows with long, impatient strides.

The boys were always glad to see Dick, but words are too feeble to express the joy they felt at his sudden and wholly unexpected appearance. For a moment they seemed to have lost the power of speech.

The trapper glanced hastily from one to the other, took in at a glance the preparations for the night, and, dropping the butt of his rifle heavily to the ground, again ejaculated:

" You keerless fellers ! "

" What's the matter, Dick ? " asked Archie, whose spirits were now as exalted as they had before been depressed. " We're all right. Sit down and have some supper."

" Youngsters," said the trapper, seating himself on the ground, and depositing his rifle beside him, " I jest knowed I would find you all right. Now, tell me whar have you been, an' what a doin' ? "

" Do you see that ? " exclaimed Archie, jumping up and pointing to the remains of the antelope, which Frank had hung up on a tree. " Do you see it ? You said we couldn't kill a prong-horn, but we've done it."

The boys then proceeded to recount their adven-
tures, telling the trapper how they had killed the
antelope, of their long ride under the scorching
sun, and how at last their horses had brought them
to the water—to all of which the trapper listened
with amazement, and feelings of admiration that he
could not disguise.

"Wal," said he, when they had concluded, "I
won't tell you to try it over ag'in, 'cause you can't
allers be so lucky."

"What did uncle say?" inquired Archie, who
was rather apprehensive of a "lecture."

"Oh, he knowed as how thar war no Injuns to
massacre you, an' when we camped fur noon, I
heered him say, 'I wonder what the boys have got
fur dinner?' I knowed me and Useless could easy
find you. That ar dog knowed jest as well that I
war arter you as I did myself."

"Well," said Frank, "whenever you get ready,
we'll go back to the camp."

"To camp!" repeated the trapper. "Haint you
rid fur enough yet? Can you stand twenty miles
more to-night?"

"Twenty miles!" echoed both the boys, in sur-
prise.

"Sartin! You're further away from the ole bar's hole now than you were last night."

The young hunters were astonished. Although they had had the Rocky Mountains for a guide-post, they had been completely turned round, and had actually traveled ten miles back toward St. Joseph.

"That's what comes of not knowin' nothin' 'bout the prairy!" continued the trapper, helping himself to a piece of the venison. "But we'll stay here to-night, an' strike fur camp in the mornin'."

The boys were very well satisfied with this ar-rangement, for their long ride had wearied them, and Archie was willing to brave grizzly bears, so long as he was in Dick's company.

After supper—which consisted of venison, with-out bread or coffee—the trapper lighted his pipe with a brand from the fire, and, settling back on his elbow, said:

"I've seed the time, youngsters, when it would n't a been healthy fur you two fellers to be out here alone. I've seed that prairy a'most black with Comanches, an have heered 'em yellin' among these ere very willows. If you had been settin'

whar you are now 'bout fifteen year ago, you would
have seed me goin' through these trees, an' swim-
min' that ar creek, with a hul tribe of yellin' an'
screechin' red-skins clost to my heels. I showed
your uncle, this mornin', the very place whar I
onct run the gauntlet of more'n a hundred Co-
manches. I tell you, youngsters, I know every
foot of this ground. Many a time me an' poor ole
Bill Lawson have skrimmaged with the Injuns
through here, when it war more'n a feller's har war
wuth to come to this creek arter a drink o' water.
But I told you 'bout runnin' the gauntlet. The
way it happened war this :

" 'Bout fifteen year ago, me an' ole Bill Lawson
war trappin' among the mountains, twenty-five
miles from the ole bar's hole. We, in course, had
fine sport, 'cause me an' ole Bill allers knowed
whar to go to find the best trappin' grounds; an',
by the time spring opened, we had as much spelter
as we could tote away on our backs. It war get-
tin' purty nigh time fur the Comanches to come
round on their spring hunt, an' we began to talk
of leavin'; but thar war plenty of beaver left in
the valley, an' we didn't like to go so long as thar
war any game to trap, so we kept puttin' it off, an'

when at last we did start, it war too late to get off
with our plunder.

"One mornin', jest at daylight, while I war in
front of the shantee cookin' my breakfast, ole Bill
come in from 'tendin' to his traps, an' said :

"'Dick, the valley's chuck full o' red-skins. I
jest seed more sign down by the creek than I ever
seed afore 'bout this place, an' that's sayin' a good
deal. We had better shoulder our spelter an' be
off to onct.'

"I didn't stop to think any more 'bout breakfast
jest then, but I ran into the shantee, grabbed my
furs, which I allers kept tied up ready for a move,
an' me an' ole Bill started out. The Injuns must
have come in durin' the night, 'cause the day afore
thar war n't a bit of sign to be seed fur ten miles
'round the valley. But we didn't stop then to
think how or when they got in, but how should we
get out. It warn't no easy thing to do, young-
sters—to go through them mountains, swarmin'
with red-skins. They don't walk through the
woods like a feller does when he's squirrel huntin',
but they go sneakin' round, an' listenin', an' peepin';
an' if a chap don't understand their natur, he'd
better not go among 'em.

" Wal, ole Bill led the way, sometimes a'most on his knees, his rifle in his hand, an' his bundle of furs on his shoulder, I followin' clost at his heels—both of us keepin' our eyes open, an' stoppin' now an' then to listen. We had made 'bout a mile up the mountain in this way, when, all to onct, ole Bill stopped and looked straight before him. I stopped, too, an' seed three big Comanches comin' along easy like, lookin' at the ground, examinin' the bushes, an' whisperin' to each other. They had found a trail that either me or ole Bill had made the day afore, an' war tryin' to foller it up. But me an' the ole man war n't the ones to leave a path that could be follered easy when we thought thar war red-skins 'round; an' I guess it bothered them rascals some to tell which way we had gone, an' how many thar war of us. But they did foller it up slowly, an' while we war lookin' at 'em they were jined by another Injun, who seemed to be a chief, for he whispered a few orders, an' two of the Comanches made off. They had been sent to rouse the camp, an' we knowed that we couldn't get away from that valley any too fast. The red-skins war n't more 'n a hundred yards from us, an' we knowed it would take mighty keerful movin' to get away

from them without bein' diskivered. But it war
life or death with us, an' we began to crawl slowly
through the bushes. A greenhorn could n't have
heered a leaf rustle if he had n't been two foot from
us; but thar's a heap of difference atween a green-
horn's ears an' them that a Injun carries. But
they did n't hear us, fur as long as we war in sight
we seed them still follerin' up the olo trail; an' as
soon as we thought we had got out of hearin' of
them, we jumped to our feet an' run like a pair of
quarter hosses. We did n't make no more noise
than we could help, but we had n't gone fur afore
the mountains echoed with the war-whoop, an' a
couple of arrers whizzed by our heads. The Injuns
had diskivered us. In course, we both dropped
like a flash of lightnin', an', while I war lookin'
round to find the varlets, ole Bill struck out his
hand, sayin':

"'This is a bad scrape, Dick, an' mebbe me an'
you have done our last trappin' together. But we
mus n't get ketched if we can help it, 'cause we
could n't look fur nothin' but the stake.'

"While the ole man war speakin', I seed one of
the rascals that had shot at us peepin' out from
behind a log. He did n't show more 'n two inches

of his head, but that war enough, an' I reckon that red-skin lay thar till his friends toted him off. Jest the minit I fired, ole Bill throwed down his furs, jumped to his feet, an' run, an' I done the same, although I did hate to leave that spelter that I had worked so hard fur all winter. But, in course, thar war no help fur it. Thar war plenty more beaver in the mountains, an', if I got safe off, I knowed whar to go to find 'em; but if I lost my scalp, I couldn't get another. So, as I war sayin', I put arter the ole man, an' jest then I heered something 'sides a arrer sing by my head. It war a bullet, an' the chap that sent it warn't sich a bad shot neither; fur, if I had the ole 'coon-skin cap I wore then, I could show you whar a piece of it war cut out. I didn't stop to look fur the feller, how-somever, but kept on arter ole Bill, loadin' my rifle as I ran. The woods war so thick we couldn't keep clost together, an' I soon lost sight of him; but that didn't skeer me, fur I knowed he could take keer of his own bacon. As fur myself, I never yet seed the Injun, or white man either, that could ketch me, if I onct got a leetle start of him; an' if all the Injuns in the mountains war *behind* me, I could laugh at 'em. But thar war some in front

cf me, as I found out afore I had gone fur. I had
jest got my rifle loaded, an' war settlin' down to
my work—makin' purty good time, I reckon, the
Injuns behind me yellin' an' hootin' all the while—
when, all to onct, up jumped about a dozen more
of the rascals.

"I did n't stop to ax no questions, but sent the
nighest of 'em down in a hurry; but in a minit
arterward I war down, too; an' when I war pulled
to my pins ag'in, I war a pris'ner, my hands bein'
bound behind me with hickory bark. It war n't a
pleasant sight I seed, youngsters, as I stood thar,
lookin' at them scowlin' Injuns. At that day thar
war few of them Comanches that did n't know me
an' ole Bill, an' when they seed who I war, they
all set up a yell, an' began dancin' 'round me like
mad, shakin' their tomahawks, an' pintin' their
rifles an' arrers at me; an' one feller ketched me
by the har, an' passed his knife 'round my head,
as though he had half a notion to scalp me to onct.
They kept goin' on in this way until all the Injuns
in that part of the woods had come up to see what
the fuss war 'bout; an' they, too, had to go
through the same motions. All to onct they hap-
pened to think of ole Bill. The chief set up a
 7

shout, an' all but four of the Injuns put off on his
trail. It showed me, plain enough, that the rascals
war afraid of me, when they left so many to
guard me. But no four of them Comanches would
have stopped me from gettin' away if I could have
got my hands free. I tell you, I done my best,
makin' that tough hickory bark crack an' snap,
but it war no go—I war fast. As soon as the
others war out of sight, one big feller ketched
me by the har, an' begun to pull me t'wards the
camp.

"He didn't help me along very easy, but dragged
me over logs an' through bushes, as if he meant
to pull my head off, while the other fellers, findin'
nothin' else to do, follered behind with switches,
that cut through my old huntin'-shirt like a knife.
At last, arter they had got me purty well thrashed,
we reached the camp, which war jest at the foot
of the mountains—I'll show you the place in the
mornin'—an' here they stood me up ag'in a post.
Then I ketched it from every body—men, women,
an' young ones. The most of the braves war still
out arter the old man, an' I could easy tell by the
way they whooped an' yelled that they hadn't
ketched him. I knowed they wouldn't get him,

neither, unless they surrounded him like they did me.

"Wal, arter tormentin' me fur a long time, an' findin' that I didn't keer fur 'em, the Injuns finally let me alone; an' one ole dried-up squaw brought me a piece of buffaler meat. They wouldn't untie my hands, but that ole woman sot thar on the ground, an' fed me like I war a baby. I eat a heap of that meat, 'cause I war hungry, an' if I got a chance to have a race with the varlets, I didn't want to run on an empty stomach; 'sides I might have to go without eatin' fur two or three days afore I could find ole Bill. Jest afore dark the braves began to come in, one arter the other. They hadn't ketched the ole man, an' I could see, by the way they scowled at me, that I would have to stand punishment for his deeds, an' my own into the bargain. I could have yelled, when I knowed the old feller war safe, an' I made up my mind that if the Injuns would only give me half a chance, I'd soon be with him ag'in.

"Wal, when the chiefs come in, I war tied fast to the post, and left thar. They didn't try to skeer me any more, 'cause they seed it war no use, an' 'sides, they wanted to save all their spite fur

the mornin', fur it war too late to begin bisness
that night. I war fast enough—as fast as if I had
been wrapped up in chains—but them Injuns war
afraid to trust me. They actooally kept half a
dozen of their braves watchin' me, from the time it
began to grow dark till daylight the next mornin'.
I didn't sleep very easy, fur I war standin' ag'in
that post, an' the bark they had tied me with war
drawed so tight that it cut into my arms; but I
made out to git a nap or two, an' when mornin'
come, an' I had eat another big chunk of that buf-
faler meat, I war ready fur 'em to begin.

"As soon as the sun war up, the chief called a
council. It didn't take 'em long to say what
should be done with me, fur sooner than I had
thought fur, one of the chiefs set up a yelp, which
war answered by the hul tribe, an' men, women,
an' children began formin' themselves into two
lines, with whips, clubs, tomahawks, or whatever
else they could ketch hold of; an' two fellers come
up to set me free. I war to run the gauntlet. I
tell you, youngsters, if thar is any thing that will
make the har rise on a feller's head, it is fur him
to stand an' look atween two lines sich as I saw
that mornin'. It warn't the fust time I had been

in jest sich scrapes, an' I knowed, too, that the Injuns did n't mean to kill me then—they wanted to save me for the stake—but somehow I could n't help feelin' shaky. I did n't let the Injuns see it, howsomever, but tightened my belt, stretched my arms, an', 'walkin' out in front of the lines, waited fur the word to start. The head of the line war t'wards the camp, an' at the foot, which war t'wards this creek, stood five or six big fellers, waitin' to ketch me when I come out.

"Wal, it did n't take me long to see how the land lay, an' when the chief yelled to let me know that the time had come, I started. The way I traveled through 'em lines war a thing fur 'em Comanches to look at. I got plenty of clips as I passed, but this war the only one that hurt me."

As the trapper spoke, he bared his brawny shoulder, and showed the boys a long, ragged scar. The wound must have been a most severe one.

"That one," continued Dick, "war made by a tomahawk. It did n't hinder my runnin', howsom-ever, an' I war n't half a minit comin' to the end of 'em lines. But when I got thar I did n't stop. The Injuns that war waitin' thar, tried to ketch me, but I passed them like a streak of lightnin',

an' drawed a bee-line fur this ere creek In course
the hul camp war arter me to onct; but I knowed
that I war safe, fur all the Injuns war behind me, an'
I would n't have been afraid to run a race with a
noss. I did n't do as well as I had done afore, nor
nigh as well as I could do now, fur I war stiff an'
lame from bein' tied up so long; but I run plenty
fast enough to git away. As I told you, I run
through these willows, swam the creek—which war
wide an' deep then, on 'count of the snow an' ice
meltin'—then tuk to the mountains, an' started to
make a circle round to the ole bar's hole. I trav-
eled in every little stream I could find; walked on
logs, an' on the second day, found ole Bill. The
ole feller had been mighty down-hearted since I
war ketched—fur the yells of the Injuns plainly
told him what had become of me—an' had never
expected to take me by the hand ag'in. But, when
he seed me safe an' sound, he sot right down on
the ground an' cried like a child.

"Wal, we lay 'round the ole bar's hole till the
Injuns had gone, an' then set out fur the fort. We
war on foot, an' had but one rifle atween us, but we
got through all right, an' in less 'n a month, war on
our way to the mountains ag'in."

CHAPTER VIII.

The "Ole Bar's Hole."

NEXT morning, after a hasty break-fast, the boys saddled their horses, and, led by the trapper, set out to find the wagon. Now it was that the latter showed the young hunters his extraordinary "travelin' qualities," as he expressed it; for as soon as the boys were in their saddles, he shouldered his rifle and started off, at a rapid pace, which he did not slacken at all until they arrived on the banks of a small stream, where they stopped to quench their thirst.

"Now, youngsters," said the trapper, seating himself on the ground, and wiping his forehead with his coat sleeve, "There's the place. The Comanche's camp war pitched jest in the edge of them ar' willows, an' right where you see them

bushes war where I stood afore I started to run the gauntlet. The chief's wigwam stood thar then. I tell you, it war n't healthy fur a feller to go foolin' 'round here them days."

The boys gazed long and earnestly at every object the trapper pointed out, and listened to his narration of the various incidents that had transpired during his captivity, until they almost fancied they could see the prairie covered with painted savages, and their guide, in the midst of his foes, awaiting the signal to begin his race for life Dick, himself, was no less interested, for he sat for a long time feasting his eyes on every familiar object; now and then casting suspicious glances toward the distant willows, as if he almost expected to catch a glimpse of a hostile warrior, or hear the war-whoop which had so often awoke the echoes of those very mountains.

"Wal, youngsters," said he, at length, "let 's be movin'! I never expected to see the time when I could travel over these ere prairies without bein' in danger of havin' my har raised; an' if you live to be as old as I am, you 'll see the day that 'em city chaps will ride through here on 'em steam railroads; an' if they see this place, they 'll never

dream that such things as I have told you about ever happened here."

The travelers again set out, Dick leading the way, at a still more rapid pace, and in two hours they arrived at the camp. Mr. Winters and old Bob were lying in the shade of the wagon, and as the boys approached, the former raised himself on his elbow, and inquired:

"Well, boys, how do you like traveling on your own hook? Do you think you could find your way to California without a guide?"

"Oh, they war all right!" exclaimed Dick, leaning his rifle against the wagon, and picking up the antelope skin which Archie had thrown down, and which contained some choice pieces of meat. "They war all right! Me and Useless found 'em down on Muddy Creek, Bob. They had killed this prong-horn, made their camp, an' war takin' matters easy like, as though they had never heered tell on a Comanche—the keerless fellers."

While Frank and Archie were unsaddling their horses, the trapper proceeded to recount their adventures, to which both Mr. Winters and old Bob listened attentively. The latter was not a little astonished to learn that the boys could so readily

accommodate themselves to circumstances, and was more firm than ever in his belief that "the youngsters would make good trappers."

Mr. Winters had, at first, been considerably alarmed at their absence; but, upon reflection, he remembered that the boys had often been in positions fully as dangerous, from which they had always succeeded in extricating themselves, and he soon fell in with the trapper's opinion, that they would "turn up all right." He did not think it necessary to caution them, for, from the description the trapper gave of their adventures, it was not at all probable that they would ever again be placed in a like situation.

After a hearty dinner, which Dick speedily served up, they again set out toward the mountains, which they reached about the middle of the afternoon. After riding along the edge of the willows, for half a mile, they came to a wide but very shallow stream, into which the trapper turned, and after following it for some distance, drove out on the bank and stopped.

"Here we are," said he, as he climbed down out of his wagon. "Now, youngsters, you're at the ole bar's hole. But if you did n't know it war

here, you might hunt fur it till your har war whiter
or Bob's, an' then you would n't find it, an' that
would n't be no wonder neither; fur many a sharp-
eyed Comanche has looked an' peeped fur it, but
only one ever found it that I know of, an' it did n't
do him no good, fur he never lived to tell of it."

While the trapper was speaking, old Bob had
dismounted from his horse, and, walking up to a
thicket of bushes which grew at the foot of a high
rock that overhung the bed of the stream, began
pulling them aside, and finally disclosed to view an
opening that appeared to lead down into the very
bowels of the earth. Meanwhile, Dick had gath
ered some dry wood for a torch, and, after lighting
it, he backed down into the hole and disappeared,
followed by Frank and Archie, who were impatient
to see the inside of the cave which had so often
served their guide as a secure retreat from his en-
emies. The passage was long and winding, and it
was with considerable difficulty that the boys worked
their way into it. Besides, it was in some places so
narrow that they could scarcely squeeze themselves
through it. The trapper, however, worked his way
along with a celerity that was surprising, and soon
both he and the torch were out of sight, and the

boys were left in pitch darkness. But there was little danger of their being lost in that narrow passage, and they crawled along as rapidly as possible, until at length Archie, who was leading the way. stopped, and began to rub his elbows and knees, which had received some pretty severe scratches from the sharp rocks.

"I say, Frank," he exclaimed, "how do you suppose Dick ever squeezed his broad shoulders through a narrow place like this? What's that?" he added, in a terrified voice, as they heard a savage growl, which seemed to sound directly over their heads.

Frank did not stop to answer, but throwing himself on his hands and knees, began to make the best of his way out of the passage, closely followed by his cousin, who urged him to go faster. They had not gone far when they were startled by the report of a rifle, which was followed by a roar that echoed and reëchoed through the cave like a heavy clap of thunder. What it was that had uttered that roar the boys were unable to determine; but they knew, by the report of the trapper's rifle, and the sounds of a fierce struggle that came faintly to their ears, that Dick had found his old harboring-

place occupied by some animal which did not feel disposed to give up possession; and they got out of the passage in much less time than it had taken them to get into it. When they reached the open air, the old trapper, who had heard the report of his "chum's" rifle, threw himself on his hands and knees, and crawled into the cave, followed by Mr. Winters. The boys at once ran to the wagon after their weapons, but by the time they had secured them, the fight was ended, and Dick made his appearance at the mouth of the passage. But he did not look like the man who had gone into that cave but a few moments before. His hunting-shirt and leggins were torn almost into shreds, his arms were bare to his shoulders, and were covered with wounds that were bleeding profusely. The boys were horrified; but their fears that the trapper had received serious injury were speedily set at rest, for he smiled as if nothing had happened, and exclaimed:

"Now you see what it is to be a trapper, young-sters. I shall allers think that 'ar cave has a good name, fur if me an' Useless did n't find the biggest grizzly bar in thar we ever sot eyes on, then thar aint no more beaver in the Missouri River."

As he spoke, he divested himself of what re-
mained of his hunting-shirt, and walked down to
the creek to wash the blood off his hands and face,
in which he was assisted by Mr. Winters. While
this was going on, old Bob crawled out of the cave,
carrying two cubs in his arms, which he presented
to the boys, saying:

"Them's young grizzlies. They do n't look
now as if they would ever get to be as big and
fierce as their mother war."

As the boys took them, they both set up a shrill
cry, and fought most desperately for such small
animals, and their sharp little claws left more than
one mark upon the hands and faces of the young
hunters.

"Keep an eye open, Bob," shouted Dick, who
was seated on the ground, while Mr. Winters was
bandaging his wounds. "Keep an' eye open,
'cause the old man of the family may be 'round."

Upon hearing this, Archie dropped his cub, and
seizing his rifle, cast anxious glances upon the sur-
rounding woods. But if the father was in the
vicinity, he evidently thought it best to keep out
of sight.

When Dick's wounds had been cared for, and he

had put on another suit of clothes, he seated himself on the ground, near tne boys, while Bob kindled a fire and began preparations for supper.

"It aint allers fun to be a trapper, youngsters," said Dick, puffing away at his pipe, "'cause, afore a man can earn that name, he's got to go through a heap of skrimmages, like the one I jest had. When I'm on the prairy, or in the mountains, I allers keep my eyes open, an' the fust thing I seed as I crawled out of that passage into that ar' cave war that grizzly bar. She seed me, too, and set up a growl, as if to tell me that I could n't get away from thar any too quick; but she did n't wink more 'n twice afore I sent a chunk of lead into her. The light of the torch, however, bothered me, an' I did n't shoot atween her eyes, as I meant to; an' afore a feller could say 'Gin'ral Jackson,' she war comin' at me. Now, I 've been in jest such scrapes afore, an' the way I 've got pawed up, an' seed other fellers that were bigger and stronger than me, clawed an' torn, has showed me that no one man that ever lived is a match fur a full-grown grizzly; an' when I seed ole Bob poke his rifle out of the passage an' draw a bead on that bar's head, I 'll allow it made me feel a heap easier. If he had stayed away five

minits longer, I do n't believe I 'd ever showed
you the way to Californy. As it war, I got pretty
well clawed up."

This was the way the trapper described the fight
in the cave, which was one of the most desperate
he had ever engaged in, as the severe wounds he
had received proved. But he looked upon such
things as a matter of course. He expected to be
engaged in many similar fights; always held him-
self in readiness for them, and when they were
over, another notch was added to those on the
handle of his knife (for Dick kept a strict account
of the number of grizzlies he killed,) and he had
another story to tell by the camp-fire.

After supper, the trappers procured torches, and,
accompanied by Mr. Winters and the boys, pro-
ceeded to explore the cave. There, lying where she
had fallen in defense of her young, was the grizzly,
which was the first of these animals the boys had
ever seen. As near as they could judge, she was
fully twice the size and weight of the bear Frank
had killed in the woods, and her claws, which she
had used with such effect upon the trapper and his
dog, (for, in defending his master, Useless had been
most roughly handled,) measured eight inches in

length. Every thing in the cave bore evidence to
the fact that the fight had been a severe one.
The floor and walls were covered with blood, and
on the bear's body were numerous wounds, made
by the knife of the trapper, and the teeth of the
faithful Useless.

After the boys had examined the bear to their
satisfaction, old Bob began to remove the skin,
while Dick pointed out other objects of interest
in the cave. There were the withered hemlock
boughs which had many a time served him and
Bill Lawson for a bed, and under them was a hole
about two feet square, which the trapper called
his "pantry." He told Mr. Winters the story of
the "struggle in the cave," and showed him the
passage that led to the top of the hill where the
Comanches had entered, and where he had for two
days kept watch, awaiting the coming of old Bill.

They remained in the cave for an hour, listen-
ing to Dick's stories; for in his mind the "Ole
Bar's Hole" was associated with many exciting
events, and it was dark before they returned to the
camp.

8

CHAPTER IX.

Archie's Adventure with a Grizzly.

N the following morning the boys, as usual, were up with the sun, impatient to try their skill on the big game, with which the woods abounded. The trapper, who, during his fight in the cave, had received wounds that would have prostrated an ordinary man, was already stirring, and, having attended to his mules, was moving about as lively as ever, preparing the morning meal. In a few moments their breakfast was cooked and eaten, and, after hanging their provisions on the trees, out of reach of any wild beast that might find his way into camp during their absence, they shouldered their rifles and followed the trappers into the forest. Here they divided into two parties, Mr. Winters going with old Bob, and the boys accompanying Dick.

"Now, youngsters," said the latter almost in a whisper, "we haint huntin' squirrels. We're ar- ter bigger game. I don't s'pose you keer 'bout tacklin' a grizzly bar arter seein' me pawed up the way I war last night; so if you happen to come acrosst one of them varmints, you needn't mind shootin' at him. Thar's plenty other game, an' what we want to find now ar' a big-horn. That's an animal, I reckon, you never seed. Go easy, now, 'cause they've got ears like a painter's, an' noses sharper nor hounds."

So saying, the trapper led the way through a narrow ravine that lay between two mountains, whose tops seemed to pierce the clouds. The ra- vine, being thickly covered with bushes and logs, rendered their progress slow and tedious, and the boys, who could not help thinking what a fine hid- ing-place it would afford for a bear or panther, often cast uneasy glances about them, and kept as close to the trapper as possible. After they had gone about half a mile, the latter suddenly stopped and said :

"If these yere trees could talk, a'most every one of 'em would have a story to tell you 'bout me an' ole Bill Lawson, 'cause we've often come through

this gully when it war chuck full of Comanches. You 'member I onct told you 'bout waitin' at the ole bar's hole fur him, an' that the ole feller had hid the black mustang in the bushes! Wal, here's the very spot."

As the trapper spoke, he pushed his way into a dense thicket, and showed the boys the sapling to which the old man had tied the horse.

" Wal, that ar' animal," continued Dick, " stood here fur two hours quiet an' still as a mouse, an' we tuk him out an' got safe off without the varlets bein' the wiser fur it. All the way through here we could hear 'em talkin' to each other, an'—Look thar, youngsters, quick!"

Before the boys could look up to see what had attracted the trapper's attention, the sharp report of his rifle rung through the gully, and a queer-looking animal come tumbling down the mountain, landing almost at their feet. Far up above the tree tops they saw the remainder of the flock bound over the rocks and disappear.

" That's a sheep," said the trapper, hastily re-loading his rifle. " He'll make a fust rate dinner, an', if we keep our eyes open, we may get an-other."

The game did bear a close resemblance to sheep, the only difference being his enormous horns, which looked altogether too large and heavy for so small an animal to carry. But the trapper did not allow them to closely examine their prize, for he exclaimed:

"If we want more of 'em fellers, we mustn't waste no time. But, fust, we must separate, 'cause the further apart we get, the more likely we are to have a shot at 'em. Are you afraid to stay here, little un?"

"Of course not," replied Archie, quickly.

"Wal, then, keep your eyes up the mountain, an' if you see 'em ag'in, blaze away. Come on, Frank. I'll show you whar to stand."

The latter moved off with Dick, and Archie was left to himself. After examining the game to his satisfaction, he took up a position where he could obtain a good view of the side of the mountain, leaned back against a tree, and impatiently waited for the re-appearance of the big-horns. In front of him ran a deer path, hard and well-beaten as any road. It was, no doubt, used as a highway by animals traveling through the ravine; and Archie now and then directed his gaze up and down the

path, in hopes he might discover some game in that direction.

He had remained in this position for nearly half an hour, when he *did* see an animal coming leisurely down the path, about fifty yards from him. It was an enormous grizzly bear. It did not appear to have determined upon any thing in particular, for it approached very slowly, stopping every few feet to snuff the air, and finally seated itself on its haunches, and proceeded to wash its paws and face, after the manner of a house cat. Archie had a good view of it. It was nearly as large as the one the trapper had killed in the cave, and the sight of its powerful claws, and the frightful array of teeth it exhibited, made the young hunter shudder. He had not been expecting so formidable a visitor, and to say that he was frightened would but feebly express his feelings. He had presence of mind enough, however, to move behind his tree, out of sight; but still he could not remove his eyes from the animal, neither could he determine upon any plan to extricate himself from his unpleasant situation. The grizzly had not yet discovered him, and Archie had his wits about him sufficiently to note the fact, that what little wind there was, was

blowing from the bear toward himself. For fully five minutes—it seemed much longer to Archie— the grizzly sat in the path, sometimes looking lazily about him, and then licking his jaws like a dog that had just enjoyed a good meal; and for the same length of time did the young hunter remain behind his tree watching his movements, and wondering what course he could pursue to rid himself of his dangerous neighbor. It was not at all probable that the bear would remain in that position until the trapper returned. What if he should take it into his head to come further down the path? Archie would certainly be discovered, for the path run close by the tree, behind which he was concealed, and what would the bear do then? It was something he did not like to think about. He knew, from what he had heard the trapper say, that the grizzly's disposition is very different from that of the black bear. The latter, unless rendered desperate by hunger, will generally take to his heels at the sight of a human being; but the grizzly looks upon all who invade his dominions as enemies, and believes in punishing them accordingly.

These thoughts passed rapidly through Archie's mind, and in a moment more his resolve was taken.

Keeping his eyes fastened on the bear, he cautiously raised his hand above his head, and, to his joy, found that he could easily reach the lowest limbs of the tree, and that they were strong enough to sustain his weight. But it was not his intention to leave the grizzly in peaceable possession of the field; for, as soon as he had satisfied himself that he had found a way of escape, he cocked his rifle and cautiously raised it to his shoulder. He was trembling violently, but at length he succeeded in quieting his nerves sufficiently to cover the bear's head with the sight and pull the trigger. The grizzly, however, arose to his feet just as Archie fired, and the ball, instead of finding a lodgment in his brain, entered his shoulder. It brought him to the ground, and Archie caught one glimpse of him struggling in the path, and heard his growls of rage and pain, as he dropped his rifle and swung himself into the lowest branches of the tree.

It was evident that the bear meant to take ample revenge on him, for Archie heard him coming up the path. But he knew that the grizzly could not climb, and, after settling himself among the branches, he looked down at his enemy in perfect security. The bear knew where he had gone, for

he ran directly to the foot of the tree, and, after smelling at the rifle and pawing it out of his way, he began walking up and down the path, all the while uttering those terrific growls, that made the young hunter tremble.

At this moment Archie heard the report of a rifle far up the mountain, which was quickly followed by another that sounded nearer. Then came a crashing in the bushes, as the big-horns fled before the hunters, and Archie heard his companions shouting to him:

"Look out, down there," said Frank; "they're running directly toward you, Archie."

"Keep your eyes open, youngster," chimed in Dick. "Don't let 'em go by you."

But Archie was not in a situation to intercept them, and he heard the big-horns dash across the ravine and bound up the mountain on the opposite side, closely followed by the dog, which barked fierce and loud at every jump.

"Archie, why don't you shoot?" again shouted Frank, his voice sounding as though he was coming down the mountain.

"I can't," answered Archie. "Look out! Don't come down here. I'm treed by a grizzly."

"By a grizzly?" repeated Frank, in astonishment. "Has he hurt you?"

"No," shouted Archie, from his tree, "I am all right; but I hurt him, I guess. Look out, Frank! he's going toward you."

This was a fact. The grizzly had stood perfectly still under the tree, listening to the sounds of the chase, until, finding that he could not reach Archie, he determined to revenge himself upon some one else. He had not gone far before Useless, having overtaken and killed a big-horn that his master had wounded, came up, and, discovering the grizzly, instantly gave chase. The bear, maddened by the pain of his wound, advanced with open mouth to meet him; but the dog, easily eluding his attacks, kept him busy until the trapper arrived, and put an end to the fight by shooting the bear through the head. Archie had watched the struggle from his perch, and, seeing that the grizzly was dead, he came down out of his tree, feeling very much relieved.

"You keerless feller!" exclaimed the trapper, "didn't I tell you not to mind shootin' at a grizzly bar?"

By this time Frank had come up with a big-horn

on his shoulder, and, after having regained his rifle, Archie gave them an account of what had transpired.

"Wal," said the trapper, "it war keerless to go a foolin' with a bar that ar' way. Now, you stay here, an' I'll go an' get that big-horn that Useless killed."

The dog, as if understanding what was said, led his master to the place where he had left the game. When the trapper returned, he removed the skin of the grizzly, intending to cure it, and give it to Archie to remember his "keerlessness by," as he said. After which, they shouldered their game and returned to **camp**.

CHAPTER X.

Hanging a Bear.

HEN they arrived at the wagon, they found Mr. Winters and old Bob eat ing their dinner. Although not as fortunate as Dick's party, they had not returned empty-handed, for the old trapper had killed a big-horn, and Mr. Winters had knocked over a large gray wolf. Thinking that Frank might want the skin of the latter to mount in his museum, he had taken it off very carefully, and stretched it on a frame to dry.

Archie's adventure with the grizzly was duly discussed, and, for an hour after dinner, the boys sat by the fire listening to the trapper's stories. But they could not long endure this inactivity— there was "no fun in it," as Archie said—so they saddled their horses and set out for a ride over the

prairie. They were not after game this time. If
they had been, it is not at all probable they would
have discovered any, for they raced their horses
over the swells, and shouted loud enough to frighten
all the animals for a mile around. About the mid-
dle of the afternoon they grew tired of their ride,
and turned their horses toward the camp. As they
rode slowly along, about half a mile from the wil-
lows that skirted the base of the mountains, Ar-
chie, who, as usual, was leading the way, suddenly
drew up his horse, exclaiming:

"See there, Frank! There's another of the
varmints!"

Frank looked toward the willows, and saw a
large, grizzly bear, seated on his haunches, regard-
ing them as if not at all concerned about their ap-
proach.

"We're safe now, Archie," said he, as soon as
he had satisfied himself that the bear had not the
slightest intention of seeking safety in flight. "A
grizzly can't outrun a horse, so let's shoot at that
fellow."

"I—I—believe I'd rather not meddle with
him," answered his cousin, shrugging his shoulders.
"I say, let him alone if he let's us alone. What

if our horses should get frightened and throw us? Would n't we be in a fix? But I 'll shoot at him from here."

"Why, it 's too far," said Frank. "I am going up nearer." As he spoke, he put his horse into a gallop and rode toward the bear, which was still seated in the edge of the willows. Archie did not at all like the idea of provoking a fight with the animal; but, after a moment's hesitation, he followed his cousin. There might be no danger after all, he thought, for that bear certainly could not catch Sleepy Sam. The grizzly still kept his seat, closely watching the movements of the hunters, and once or twice he seemed inclined to advance on them; but, after walking a few steps, he again seated himself, as if to await their approach.

The boys had gone but a short distance, when their horses discovered the animal, and Pete at once stopped, and refused to go any further. He had evidently had some experience in bear hunting, for the sight of the animal seemed to terrify him. Words had more effect than the spurs, for when Frank spoke encouragingly to him, he would advance a few steps, and then, as if suddenly recalling his former experience, he would hastily

retreat. In this way, he succeeded in getting
further and further away from the bear, instead
of going toward it. Archie now took the lead, in
hopes that his cousin could induce his horse to
follow the old buffalo hunter; but Pete utterly re-
fused to go any nearer, and Frank at length dis-
mounted and prepared to risk a shot at the bear at
long range. The animal accepted this as a chal-
lenge, for he arose to his feet, growling savagely,
and made toward the boys at a rate of speed that
astonished them.

When Frank dismounted, he was careful to re-
tain a firm hold of Pete's bridle, for the actions of
the horse plainly indicated that, if left to himself,
he would take to his heels, and get as far as possi-
ble away from the dangerous neighborhood. When
he saw that the bear was coming toward him, he
snorted and plunged, rendering it impossible for
Frank to shoot; and, in fact, the latter had no de-
sire to do so, when he found that the grizzly was
about to assume the offensive. His first thought
was to remount; but the horse was so terrified
that he would not stand still long enough for Frank
to place his foot in the stirrup.

"Hurry up, there!" exclaimed Archie, excitedly.

"The rascal is coming fast. He means fight, sure enough."

Pete evidently thought so too, for he reared and plunged worse than ever, pulling Frank about over the prairie in spite of all he could do. Suddenly there was a loud snap, and the bridle, broken close to the bit, was violently pulled through Frank's hand. The next moment Pete had disappeared behind a swell. For an instant the cousins gazed at each other in dismay. On foot, Frank could not hope to escape from the bear, which, in spite of his clumsy appearance, was making his way toward them with surprising rapidity; neither could he disable him by a shot from his rifle. Before, he had been as cool and collected as he possibly could be, for he knew that he had a way of escape. But Pete seemed to have carried the last particle of his master's courage away with him, for Frank's hand trembled so violently that he knew it would be useless to fire at the bear. But still there was a chance for escape, and Archie was the first to think of it.

"Frank!" he exclaimed, " there 's only one way now—jump up behind me."

His cousin was prompt to act upon the sugges-

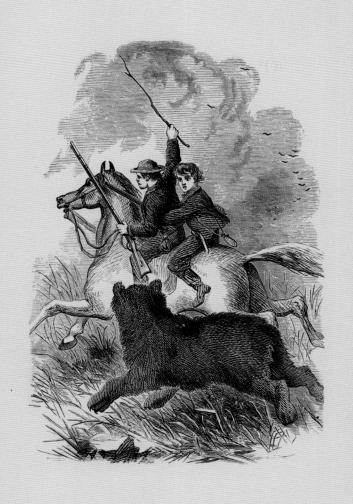

tion, and Sleepy Sam, in answer to a thrust from his master's spurs, carried them both toward the camp at a rapid gallop.

They no longer thought of fighting the grizzly; their only desire was to reach the old bear's hole as soon as possible, and procure the assistance of the trappers. They both thought that the animal would soon abandon the chase, and their only fear was, that before they could reach the camp and acquaint Dick with what had transpired, the bear would be safe among the mountains. But they soon discovered their mistake. The grizzly steadily followed them, and, although Sleepy Sam made excellent time for a horse encumbered with a double load, gained at every step. But they were rapidly nearing the old bear's hole, and, at length, the boys saw their uncle and the trappers ride out of the willows. Dick was mounted on Frank's horse. The animal, when he found himself at liberty, had made straight for camp, and his appearance there, without his rider, occasioned no little surprise and alarm. Dick, as usual, predicted that "Frank war n't a bit hurt. He would be sartin to turn up all right." But still he did not know but the young hunter had got himself into "some

9

scrape," in which he would need assistance, and
agreed with Mr. Winters that it would be best to
hunt him up. The latter was fast falling in with
the trapper's opinion, that his nephews were
" 'bout the keerlessest chaps agoin';" and although
he knew that they always succeeded in bringing
themselves " safe out of all their scrapes," he felt
considerably relieved, when he saw that Sleepy
Sam had carried them out of reach of the claws of
the grizzly.

Archie, when he found that assistance was at
hand, stopped and faced the bear, intending to try
a shot at him. But the trappers galloped toward
them, Dick shouting, "Hold on thar, you keerless
feller; me an' Bob 'll take him off your hands.
We 'll show you how they hunt bars in Mexico.
We 'll hang the varmint."

The trapper swung a lasso above his head, as he
spoke, and brought it down across Pete's sides, in
a way that made the spirited animal prance in the
most lively manner. The horse was still unwilling
to approach the bear; but he knew full well that
he carried a rider who was able to enforce obedi-
ence.

The grizzly stopped for a moment when he saw

these new enemies approaching, then he rushed
toward old Bob, who was in advance of his com-
panion. But he was met by the trapper's dog,
which attacked him with such fury that the bear
was obliged to stop and defend himself. Old Bob
rode in a circle around the combatants, holding his
lasso in his hand all ready for a throw, and yelling
with all the strength of his lungs to encourage the
dog. Dick was making desperate efforts to join
his companion, but his horse stopped about a hun-
dred yards from the bear, and stubbornly refused
to go nearer. His rider, resolved to have his own
way, beat him most unmercifully with his lasso,
and, as the horse appeared to be equally deter-
mined, the boys were unable to decide how the battle
would end. All this while Useless had kept up the
contest with the bear, and the animal finding that
he could not elude his attacks, rose on his haunches
and struck at the dog with his paws. Old Bob
had been waiting for this. Swinging his lasso
around his head, he launched it at the bear, and
as the noose settled down about his neck, he turned
his horse and galloped off. The next moment
there was a heavy thud, a smothered growl of
rage, and the grizzly was prostrate on the prairie.

He, however, quickly regained his feet, and, disre-
garding the attacks of the dog, rushed with open
mouth toward old Bob. Now was the time for Dick.
Having, at last, been whipped into obedience, Pete
gamely approached the bear, and, in an instant
more, grizzly was powerless. Dick was on one side
of him, old Bob on the other; and their lassos
were drawn so taut he could not turn either
way. If he attempted to attack Bob, he was
checked by Dick; and if he rushed upon the lat-
ter, old Bob's lasso stopped him. The grizzly's
struggles were desperate; his growls terrific. He
tore at the lassos with his claws, and exerted all
his tremendous strength to break the raw-hide
ropes, which were drawn as tight as a bow-string.
But the conflict, desperate as it was, lasted only a
short time. The grizzly's struggles grew weaker, his
growls fainter, and finally he sank on the prairie dead.
The trappers slackened up their lassos, and Mr.
Winters and the boys, who had closely watched
this singular contest, rode up to examine their prize.

"Thar's your bar, you keerless fellers," said
Dick. "If you do n't let these yere varmints
alone, you'll git yourselves in a bad scrape, one
of these days, now, I tell you A grizzly do n't

wait fur a feller to walk up an' shake his fist in his face, an' say, 'Do ye want to fight?' He b'lieves in makin' war on every one he sees."

"We know that!" replied Archie. "This fellow made at us before we got near enough to shoot at him."

"Then you did mean to fight him, did you?" asked the trapper, as he and old Bob began to skin the bear. "Wal, it aint every feller that would keer 'bout meddlin' with a grizzly so long as the critter let him alone. I've seed trappers—an' brave ones, too—that would shoulder their we'pons an' walk off if they happened to come acrost a bar. It aint allers fun to hang a grizzly, neither; fur if your hoss falls down, or your lasso breaks, you 're a'most sartin to go under. I've seed more 'n one poor chap pawed up 'cause his hoss war n't quick enough to git out of the varmint's reach."

In this way the trapper talked to the boys until the skin of the grizzly was taken off, when the travelers returned to their camp. As Archie remarked, it had been "a great day for bears," and the evening was appropriately passed in listening to the stories the trappers related of their adventures with these animals.

CHAPTER XI.

A Buffalo Hunt.

HE next morning, after breakfast, the boys seated themselves by the fire, and while Frank mended his bridle, which Pete had broken the day before, Archie was endeavoring to conjure up some plan for the day's amusement. Even in that country, which abounded with game, the boys were at a loss how to pass the time, for the grizzlies had interfered with their arrangements considerably. If they went hunting in the mountains, they might come across another bear; and their recent experience with those animals had shown them that the hunters were sometimes the hunted. They had no desire for further adventures with the monsters, and they had at last decided that they would take a gallop over the prairie, when they were startled by the clatter of horses'

hoofs in the creek, and old Bob—who, at daylight,
had started out on a "prospecting" expedition—
galloped into camp, breathless and excited. The
boys very naturally cast their eyes toward the
prairie, to see if he were not followed by a grizzly;
but the sight of one of those animals never affected
the old trapper in that manner. He had seen what
he considered larger and more profitable game.

"Dick," he exclaimed, drawing up his horse with
a sudden jerk—"Dick, have some buffaler hump
for dinner?"

"Sartin," replied the trapper, hastily rising to
his feet, and throwing away his pipe. "In course.
Saddle up to onct, youngsters. We'll have some
game now as is game."

The announcement that there is a herd of buffa-
loes in the vicinity, always creates an uproar in a
hunter's camp, and there was no exception to the
rule this time. The boys had never seen the trap-
per so eager; and even Mr. Winters, generally so
cool and deliberate, was not so long in saddling his
horse as usual. This, of course, had an effect upon
the boys; but, as is always the case, their hurry
occasioned them a considerable loss of time. Ar-
chie could not find his bridle, and Frank, in his

eagerness, broke his saddle-girth; and, to increase
their excitement, the others, as soon as they had
saddled their horses (Dick rode one of the mules)
and secured their weapons, rode off, leaving them
alone. Archie, after a lengthy search, found his
bridle in the wagon, and Frank at last succeeded
in mending his saddle-girth with a piece of buck-
skin. The boys' rifles stood together against a
tree, close by, with all the accouterments hanging
to the muzzles. Frank's being a common "patch"
rifle, he, of course, had a powder-horn and bullet
pouch, while Archie carried the ammunition for his
breech-loader in a haversack. The latter was ready
first, and hastily seizing the gun that came first to
his hand, secured Frank's instead of his own, and,
putting his horse into a gallop, rode down the bed
of the creek, throwing the powder-horn and bullet
pouch over his shoulder as he went. Frank was
ready a moment afterward, and finding his own
rifle gone, he, of course, took Archie's. Although
he thought nothing of it at the time, he afterward
looked upon it as a lucky circumstance. In addi-
tion to their rifles, the boys each had two revolv-
ers, which they carried in their holsters. Frank
overtook the hunters at the edge of the prairie,

where they had stopped to wait for him, and to hold a consultation. The high swells that rose in every direction shut them out from the view of the game, but old Bob knew exactly where to go to find it. As they went along, at an easy gallop, Dick rode up beside the boys, and, addressing himself to Frank, said:

"Now, youngster, this 'll be new bisness to you, so don't be keerless. You must 'member that your hoss ar' as green as a punkin in buffaler huntin', an', if you let him get stampeded, he 'll take you cl'ar to Mexico afore he stops."

"Stampeded!" repeated Frank. "Does a horse ever get stampeded with buffaloes?"

"Sartin he do," answered the trapper, with a laugh; "an' if you ever get teetotally surrounded by a thousand bellerin', pitchin' buffalers, you 'll say it 's the wust scrape you ever war in. So don't go too clost to 'em. If your hoss gets frightened, stop him to onct, and quit follerin' 'em."

Dick was then proceeding to instruct the boys in the manner of hunting the buffaloes, when old Bob, who had been leading the way, suddenly came to a halt.

"They're jest behind that swell," said he.

"Don't you hear 'em? Now, we must separate."
Then, in hurried whispers, he pointed out the sta-
tion he wished each to occupy, and, after Dick had
again cautioned Frank to keep his horse com-
pletely under his control, the boys rode away in
different directions.

When Frank reached his station, he stopped his
horse, examined his rifle, opened his holsters, so that
he could readily draw his revolvers, and waited im-
patiently for the signal. The hunters were sta-
tioned about a quarter of a mile apart. Old Bob
was in the center of the line. After satisfying
himself that they were all in their places, he waved
his hat—the signal for the advance. They all
started at the same moment, and, before Frank
could think twice, his horse had carried him to the
top of the swell, and he was in full view of the
game. The sight that met his eyes astonished
him.

He had often read of the prairie being black
with buffaloes, but he had never seen it before.
The herd was an immense one, and stretched away
in all directions as far as his eye could reach. But
he was allowed no time for admiration, for, the
moment the hunters made their appearance, the

buffaloes discovered them, and made off at the top of their speed, the noise of their hoofs sounding on the hard prairie like the rolling of thunder. Pete was not afraid of buffaloes, and he soon carried his master within easy range of the herd, the nearest of which fell at the crack of his rifle. Too impatient to reload his gun, Frank drew one of his revolvers, and, forgetting, in his excitement, all the trapper's advice, spurred after the flying herd; and, so close was he to them, that he seldom missed his mark. When he had fired all the charges, he returned his empty weapon to his holster, and, as he drew the other, he cast his eye in the direction of his companions, and was a good deal surprised to discover that some of the herd had got between him and the rest of his party, and were running almost side by side with him. On the outer edge of the herd, he saw his cousin in company with the trappers. Archie had, doubtless, emptied all his weapons, for he appeared to be engaged in reloading. Further back, he saw Mr. Winters, who had stopped to "settle" a large bull he had wounded. He also noticed that the mule, on which Dick was mounted, being entirely unaccustomed to such business, and frightened by the

discharges of the fire-arms, and the noise of the rushing herd, was making desperate but unsuccessful attempts to throw his rider. Frank, taking this all in at a glance, then turned his attention to the animals nearest him, and soon emptied his second revolver.

All this while Pete had been running with the bridle hanging loose on his neck; now, as Frank gathered up the reins, he noticed, for the first time, that he was going at a rate of speed he had never before accomplished. This, however, did not alarm him; but, seeing that he was leaving his companions behind, he thought he would slacken his pace and wait for them to come up. He drew in the reins, but it had no effect on the horse, which, looking back over his shoulder, as if frightened at something that was pursuing him, bounded off faster than ever. Taking a firmer hold of the reins, Frank pulled again with all his strength, but to no purpose. Had he been at sea, in an open boat, without rudder, sails, or oars, he could not have been more helpless than he was at that moment. His horse, perfectly unmanageable, was running away with him! In an instant, the thought flashed through Frank's mind, that he was

in the very position the trapper had so emphatically cautioned him to avoid. But still he was not frightened, until he cast his eyes behind him, and, to his utter dismay, discovered that the herd had closed in on all sides of him. Around his horse was a clear space of perhaps a hundred yards in diameter, which was slowly but surely growing smaller, as the frightened animals pressed and crowded against each other. On every side he saw a mass of horns, and tails, and shaggy shoulders, which, like a wall, shut him away from his companions. Away off to the right, he saw the trappers, Archie, and Mr. Winters, no longer pursuing the game, but gazing after him, and throwing their arms wildly about. If they shouted, Frank did not hear what they said, for the noise of that multitude of hoofs would have drowned the roar of Niagara. They could not assist him, neither could he help himself. That very morning the trapper had told him of seeing a man trampled to death by a herd of buffaloes, and now a similar fate was in store for himself. The appalling thought seemed to deprive him of the last particle of strength, for he reeled in his saddle, and only caught the mane of his horse just in time to save himself from fall-

ing to the ground. But, as was always the case
with Frank, when placed in situations of extreme
danger, this burst of weakness quickly passed.
While he had life, he could not relinquish all hope
of being able to bring himself safely out of even
this, the most perilous position in which he had
ever found himself. He could determine upon no
particular plan for escape, so long as he was sur-
rounded by those frantic buffaloes. The only
course he could pursue was to compel Pete to
keep pace with the herd. But this plan did not
place him out of the reach of danger. He knew
that buffaloes, when stampeded, turn aside for
nothing. Neither hills nor rivers check their mad
flight, and any living thing that stands in their way
is trampled to death. Even the exhausted mem-
bers of the herd, unable to keep pace with the
others, are borne down and crushed to a jelly.
They neither seem to hear or see any thing; all
their senses being merged into the desire to get as
far as possible from the object that has excited
their alarm; and they seldom stop until completely
exhausted.

Frank knew this, and the question that arose in
his mind was, "How long could his horse stand

that rapid gallop?" He appeared to be as thoroughly frightened as the buffaloes, and it was not at all probable he would show any inclination to stop, so long as he saw that shaggy mass behind him, or could hear the noise of their hoofs, which sounded like the rumbling of an immense cataract. The more he thought of his critical situation, the firmer was his belief that there was but one way open to him, and that was to keep ahead of the animals, which were behind him. Having determined upon this, he again cast his eyes toward the place where he had last seen his friends. They were gone, and Frank was alone in the midst of that multitude of frantic buffaloes.

When the trappers had discovered Frank's situation, they knew it was out of their power to assist him. After following him a short distance, in the vain hope of making him hear the words of advice and encouragement which they sent after him with all the strength of their lungs, they had fallen back out of sight. Dick had advised this course, "Fur," said he, "the longer we foller 'em, the faster they'll run. They won't stop till they're clean gin out. If the youngster stays on his hoss, an' keeps

ahead of 'em till they're a leetle over their fright, he's all right."

Dick, however, did not intend to leave his young companion altogether. At his request, Archie gave up Sleepy Sam to him, and, after assuring the others, who were in a state of intense excitement and alarm, that he would certainly find Frank and bring him back safe, he rode off in the direction the buffaloes had gone, while the rest of the party returned to collect their game.

Meanwhile, Pete, rendered frantic by the deafening noice, was carrying Frank over the prairie at a terrific pace. The young hunter's alarm had somewhat abated, and he appeared as calm as though he was merely taking a ride for amusement; but his mind was exceedingly busy, and, in a very short space of time, he lived over his whole life. He cast frequent and anxious glances behind him, but could see no change for the better in his situation. The buffaloes, as far as his eye could reach, pushed and crowded against each other, apparently as frightened as ever, but taking no notice whatever of the horseman in their midst. The space around his horse was gradually growing smaller, which

made Frank shudder when he thought what the
result would be if they should close in upon him.

One hour passed, and still the frightened herd
dashed on, with the frantic horse and his helpless
rider in their midst, without, in the least, slacken-
ing their pace. Pete was evidently in distress.
That mad gallop was telling on him severely; but,
while those buffaloes were behind him, all attempts
to stop him would have been useless. Another
hour glided by, and, to his joy, Frank discovered
that the animals behind him were scattering, and
that the line of his pursuers was growing thinner.
Those in front still ran as fast as ever—no doubt,
pushed onward by those behind them, while those in
the extreme rear were evidently getting over their
fright. Frank looked again and again, to satisfy
himself that he was not mistaken, and he was con-
fident that, if his horse could hold out half an hour
longer, the buffaloes, slowly dividing right and left,
would leave a way of escape open to him. The
minutes seemed lengthened into hours; but his
pursuers were now rapidly taking up their places
on the flanks of the herd, and, in a short time, not
a buffalo was to be seen behind him.

Again Frank pulled the reins, and Pete, almost
10

exhausted, and no longer hearing that terrific noise
behind him, willingly stopped. Frank, filled with
gratitude for his escape, threw himself from the
saddle, just as the last of the buffaloes were disap-
pearing over a neighboring swell.

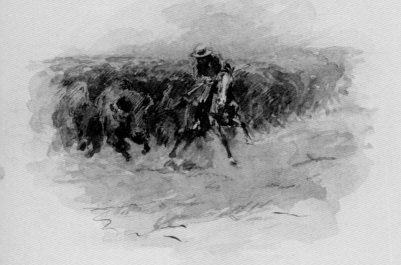

CHAPTER XII.

A Night among the Wolves.

T would be impossible to describe Frank's feelings, as he stood there, holding his panting, reeking horse, and listening to that rumbling sound, which grew fainter and fainter, as the buffaloes dashed on their way. Now that the danger of being trampled to death was passed, he did not stop to think of what was still before him. He cared not that he was forty miles from the old bear's hole, and that, in three hours, the sun would be down, and he compelled to pass the night alone on the prairie. All thoughts of what he knew he must endure before he reached the camp were swallowed up in thankfulness that he had been able to bring himself safely out of the most dangerous position in which he had ever been placed.

In a few moments the last of the buffaloes had passed out of hearing, and Frank then turned his attention to his horse.

Pete looked very unlike the sleek, spirited animal of which he had been so proud. He was reeking with sweat, panting loudly, and was evidently very nearly exhausted. Had he been obliged to carry his rider a few miles further, Frank might have been compelled to find his way back to camp on foot. Pete was also very much in need of water; and now that the danger was over, Frank found that he, too, was very thirsty. During his excitement and alarm he had not thought of it; but now that he was able to think calmly, he decided that his first care should be to find a stream of water, where he might quench his thirst.

After reloading his rifle and revolvers, he again took Pete by the bridle and led him in the direction of the mountains, which, as near as he could judge, were twenty miles distant. Although he was most anxious to reach them before night, in hopes that he might find the trapper, (for he knew that Dick would not rest easy until he had found him,) he could not bear the thought of riding his horse while he was in such distress.

At length he reached the top of a swell, when he paused to look about him. On his right hand, about a mile distant, as he judged, he saw a long line of willows, which (so the trapper's had told him) were a sure sign of water. Toward the willows, then, he directed his course, in hopes that his horse, when he had quenched his thirst and eaten a few mouthfuls of grass, would be in a condition to travel. But he soon found that it was more than a mile to the willows—it was five times that distance—and it was about an hour before sunset when Frank reached the stream, and, kneeling down on the bank, took a long, refreshing drink. Here he had a most lively battle with Pete. The horse was stubborn, and when he had determined upon a course, it required considerable persuasion to induce him to abandon it. He wanted to drink his fill of the water at once, to which Frank objected; and it was not until Pete had received several severe blows from a branch that his master cut from one of the willows, that he allowed himself to be led out of the stream. Frank then tied him to a tree, removed the saddle, and threw himself on the ground to determine upon his future movements. He was tired and

hungry; he did not like the idea of camping on
the prairie alone, but he could see no way to
avoid it. Then he thought of the trapper, and
walked out on the prairie to look for him. But
Dick was nowhere to be seen. Had Frank re-
mained where he had escaped from the buffaloes,
he would then have been in the company of his
friend, for the trapper was at that moment stand-
ing on the top of the very swell, where Frank had
stood when he first discovered the willows. Use-
less sat by his side, looking up into his master's
face, and whining as if he, too, wondered what had
become of the object of their search. Seeing no
signs of Frank, Dick concluded that he was still
among the buffaloes, so he kept on after them, now
and then shaking his head and muttering—"The
keerless feller. It beats all natur' how that hoss
of his 'n traveled." But Frank did not know that
Dick was so near him, and, after waiting nearly
an hour for him to make his appearance, he re-
turned to the willows, and sat about making his
preparations for the night. He first selected a
suitable spot for a camp, and, after gathering a few
dry branches and lighting a fire with a flint and
steel he found in Archie's haversack, he took his

rifle and walked along the bank of the creek to find something for his supper. He generally took great pleasure in a hunt, but there was no sport in this one, for he could not help thinking of his recent adventure with the grizzly. What if he should meet one of those animals? He could not hope for assistance from the trapper. He had no one to depend upon but himself. He had always had great confidence in his skill as a marksman, but he had never wished for an opportunity to try it on a grizzly bear. If there were any of those animals among the willows, he did not encounter them, and, in fact, the woods did not appear to abound in game of any kind. The only living thing he discovered was a raccoon crossing the creek on a log just ahead of him.

Frank, knowing that he was working for his supper, made a good shot, and when he shouldered the 'coon and started for his camp, he felt relieved to know that he was not compelled to pass the night hungry. He had often heard that the flesh of the 'coon was excellent, and he found it was so; whether it was because he was hungry, or because the meat was really good, he could not decide; but at any rate, he ate nearly half the 'coon, and

hung the remainder upon a limb to save it for his breakfast. Then, after gathering a supply of fire-wood, sufficient to last all night, he again walked out on the prairie to look for the trapper. But he was not in sight; and when it began to grow dark, Frank returned to his camp, feeling rather lone-some. After he had hobbled Pete, (which he did by tying one end of his halter around his neck, and the other to one of his fore legs,) and turned him loose to graze, he seated himself by the fire, and heartily wished it was morning.

There was nothing pleasant in the thought that he was obliged to pass the night alone. He had often camped out, but he was not accustomed to living in such a wilderness. Had Dick been with him, he would have slept as soundly as he ever did at home; but, as it was, there was no probability of his enjoying a good night's rest. It grew dark rapidly, and the prairie, so deserted and still in the day-time, now seemed to be crowded with wolves. He had heard them every night since he had been on the plains, but he had never listened to such a chorus as saluted his ears that evening. The fact was, they had been attracted by a buffalo that lay but a short distance from Frank's camp. It had

been wounded by the hunters in the morning, and, becoming separated from the herd, had come to the creek for water, and died. Frank knew that the wolves had found something, for he could hear them growling and fighting over their meal. Suddenly they all set up a howl, and took to their heels. They did not go far, however, but appeared to be running in circles about their prey, as if they had been driven away by some larger animal. Frank was not pleased with his neighbors, and did not feel at all inclined to go to sleep. He sat before his fire, with his rifle across his knees, and his revolvers close at hand, sincerely hoping that the wolves would not approach his camp. For two hours he remained in this position, and finally, becoming more accustomed to the howls of the wolves, he leaned against a tree, and was fast losing all consciousness of what was going on around him, when he was aroused by his horse, which came snorting through the willows, and did not stop until he had placed himself close to his master for protection. This alarmed Frank, who, remembering how Pete had acted the day before, was certain that there was a grizzly bear prowling about his camp; and, fearful that his horse, if left to him-

self, would run away, he slipped the bridle over his head, and tied him securely to a tree. While thus engaged, he heard a slight noise in the bushes, as if some heavy animal was endeavoring to pass carefully through them. This continued for half an hour, during which the animal, whatever it was, walked entirely around his camp. This tried Frank's nerves severely. To sit there, in those woods, and listen to some animal walking about, perhaps watching for an opportunity to spring upon him, was almost as bad as facing a grizzly. Again and again the animal made the circuit of the camp, and presently Frank saw a pair of eyes, that looked like two coals of fire, glaring at him through the darkness. Should he fire at the animal? If it was a grizzly, and the wound should not prove fatal, his life would not be worth a moment's purchase. There might be bushes between him and the beast, that would glance the ball, or his hand might prove unsteady. It was a risk he did not like to take; but he could try the effect of fire on him. So, catching up a brand, he threw it at the eyes, which instantly disappeared.

During the livelong night did Frank sit by the fire, holding his rifle in his hands, now and then

caressing his horse, which stood close beside him, trembling with fear; while, at regular intervals, he heard a rustling in the willows, which told him that his enemy was still on the watch.

But all things have an end. At length, to Frank's immense relief, day began to dawn. As soon as he could distinctly discern the nearest objects, he again hobbled his horse, and, after turning him loose to graze, began to prepare his breakfast. After he had cooked and eaten the last vestige of the 'coon, he saddled Pete, and, turning his back upon the place where he had passed a most uncomfortable night, set out toward the mountains.

About the same hour, the trapper arose from the prairie, where he had made his camp, and where he had slept soundly, in spite of the howling of the wolves, and, mounting Sleepy Sam, began to follow up the trail of the buffaloes. Each was looking for the other, and both were traveling in exactly opposite directions.

Frank had a long ride before him, and it was monotonous and tiresome. Pete appeared to have fully recovered from the effects of his long run, for he carried his rider at a rapid pace; but, at sunset, Frank had not reached the mountains. He

could not bear the thought of camping on that bare
prairie, where he could have no fire, and he re-
solved to ride until he reached the timber at the base
of the mountains, if it took him until midnight.
Darkness settled down over the prairie, and, a
short time afterward, he reached the woods. As
he rode slowly along, in the hope of discovering
some stream, on the banks of which he could
camp, he saw a light shining through the trees.
A second look showed him that it was a camp-fire.
No doubt he would find Dick there. Without hes-
itating an instant, he put spurs to his horse, and
rode up in full view of the fire, around which he
saw four men lying on their blankets.

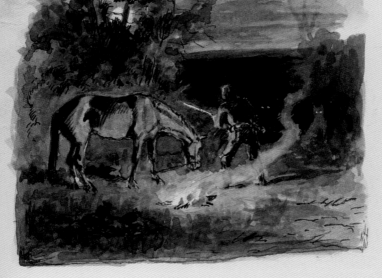

CHAPTER XIII.

Frank's New Acquaintances.

RANK'S sudden appearance created considerable of a commotion in the camp, for the men sprang to their feet and reached rather hurriedly for their weapons. They were evidently alarmed; and Frank was a good deal surprised thereat, for he had not dreamed that men accustomed to the dangers of the prairie— as these undoubtedly were—could be frightened at the sudden approach of a single bewildered horse-man. He, however, rode straight up to the fire, where the men stood with their rifles in their hands, and exclaimed, as he dismounted from his horse:

"Good evening, gentlemen!"

His politeness did not serve to allay the fears of the men, for they regarded him sharply for a moment, and then one of them asked, in a voic

that somewhat resembled the growl of an enraged
bear:

"What do you want?"

"I am lost," replied Frank. "My horse was
stampeded with a herd of buffaloes, and I am now
making the best of my way back to my friends."

The man slowly surveyed him from head to foot,
and then answered, in a tone of voice which showed
that he did not believe Frank's statement:

"Lost! Lost, aint ye? Wal, what in tarna-
tion are ye lost fur? Why don't ye go whar ye
b'long?"

"That's what I want to do!" replied Frank,
who, astonished at the manner in which he was re-
ceived, and fearful that he would be compelled to
pass another night alone on the prairie, did not
notice the sly, meaning glances which the men ex-
changed. "I am trying to find my friends. I left
them at the 'old bear's hole,' if you know where
that is."

This statement was received with something like
a long breath of relief by the trappers—for such
they undoubtedly were—and the spokesman con-
tinued:

"Then, ye're sartin ye're lost, an' that ye aint

got no friends nigher nor the ole bar's hole? Who war ye travelin' with? Who's yer comp'ny?"

"Dick Lewis and old Bob Kelly," replied Frank, mentioning the names of the guides, with the hope that some of his new acquaintances might know them; nor was the hope a vain one, for the trappers repeated the names, and again exchanged those sly glances, which Frank noticed but could not understand:

"So ole Bob is yer comp'ny," said his questioner, at length; "an' ye're sartin ye left him at the ole bar's hole! Then, ye won't be likely to set eyes on him to-night, 'cause the bar's hole ar' a good fifty mile from here, an', if ye're actooally an' sartinly lost, ye aint no ways likely to find it in the dark."

The trapper was evidently forgetting his fears and recovering his good nature—if he possessed that quality—for, as he resumed his seat at the fire, he continued, in a somewhat milder tone:

"If yer hoss war stampeded, stranger, he must be powerful lively on his legs to have tuk ye so fur; but, I reckon, ye must be travelin' a leetle out of yer latitude. It aint often that a feller meets a tee-total stranger in these parts what says he's lost, an'

we do n't like to take in every one as comes along;
but, if so be that ye are a friend of Dick an' ole
Bob, ye can hobble yer hoss an' camp here with
us. Ye can sleep by our fire to-night, an' in the
mornin' we 'll set yer on the right track."

Frank gladly complied with this invitation, and,
after relieving his horse of the saddle, he seated
himself at the fire, and began to make a close ex-
amination of his new acquaintances. They were
all large, muscular men, and were dressed in com-
plete suits of buckskin, which were very ragged
and dirty. Their faces were almost covered with
thick, bushy whiskers, and their hair, which, judg-
ing by its tangled appearance, had never been
made acquainted with a comb, hung down to their
shoulders. The man who had acted the part of
spokesman, was particularly noticeable, being more
ragged and dirty than his companions, and his
face, which bore several ugly scars, was almost as
black as a negro's.

In short, they were a very ferocious looking set,
and Frank almost wished he had remained on the
prairie instead of coming to their camp. But,
after all, he might be very much mistaken in his
men. It was not to be expected that persons of

their calling, who had no doubt lived on the prairie
from boyhood, who had been exposed to all kinds
of weather, and braved innumerable dangers, it
could not be expected that such men should always
present a neat appearance. Beneath their rough
exterior there might be hidden the warmest of
hearts. And as for their reception of him, they
had doubtless treated him as they treated every
stranger they met on the prairie—on the prin-
ciple, "Believe every man an enemy, until he
proves himself otherwise."

While these thoughts were passing through
Frank's mind, the trappers had been regarding
him closely and with evident curiosity.

The result of their examination appeared to
be satisfactory, for the spokesman presently re-
marked:

"It's plain, stranger, that yer out of yer callin'.
Ye do n't b'long on the prairy. Yer from the
States, we take it."

Frank replied that he was, and then proceeded
to give the trappers an account of the circum-
stances that had brought him to the prairie, and
also told how he had made the acquaintance of
Dick and old Bob; to all of which the men listened

11

eagerly, now and then exchanging the same sly glances that Frank had before noticed. When he had finished his story, the swarthy trapper arose to his feet, and, going to a tree close by, took down a piece of buffalo meat, from which he cut several slices that he placed on the coals, remarking as he did so:

"Whenever we do meet a stranger in these parts, an' he turns out to be the right kind of a chap, we allers treat him as handsome as we know how. We can't offer you anything more 'n a chunk of buffaler hump, but sich as we have yer welcome to."

The offer was evidently made in all sincerity, and if Frank still entertained any fears that the men were not what they should be, he speedily dismissed them, and again blessed his lucky stars that he was not compelled to pass another night alone on the prairie.

While his supper was cooking, he was again plied with questions, the most of them relating to the movements of old Bob; and especially did the trappers seem anxious to learn where he was going, and what he intended to do when he returned from California. Frank answered these questions as

well as he could, and his replies seemed to satisfy
the men, one of whom finally changed the subject
of the conversation, by remarking:

"I'll allow that's a fine shootin' iron of your 'n,
stranger, but it's a new-fangled consarn, I should
say."

Frank, it will be remembered, had Archie's rifle,
which, being a breech-loading weapon, was some-
thing the trappers had never seen before, and it
required considerable explanation to enable them
to understand "how the consarn worked."

From his rifle they went to the other articles of
his "kit." The contents of his haversack were
examined, the qualities of his hunting-knife and
revolvers discussed, and then they turned their at-
tention to his horse—made inquiries concerning
his speed and bottom, until, weary with their ques-
tioning, they stretched themselves out by the fire
and went to sleep.

After eating his supper, Frank followed their
example; and, being completely exhausted, having
scarcely closed his eyes during the preceding night,
he slept soundly until morning.

When he awoke it was just daylight. The trap-
pers had already arisen; the fire had been replen-

ished, and several slices of meat were broiling on
the coals.

They hardly noticed Frank; the only reply his
polite greetings received, being a sort of grunt
and a slight nod of the head. After washing his
hands and face in the creek that ran close by—a
proceeding which the trappers regarded with un-
disguised contempt—he seated himself at the fire
with the others and began helping himself to the
meat, at the same time inquiring the way to the old
bear's hole.

"That ar' is the way, stranger," replied the
swarthy trapper, pointing in a direction exactly
contrary to the one Frank had pursued the day
before; "an', as I told ye last night, it's nigh on
to fifty miles off."

After this, they again relapsed into silence, and as
soon as they had finished their breakfast, went out
to catch their horses. Frank accompanied them;
all his old fears that there was something wrong,
revived with redoubled force, and he was anxious
to leave the company of his new acquaintances as
soon as possible. When he had caught and saddled
Pete, he left him standing for a few moments, until
he secured his rifle and haversack, and when he

turned to mount, he saw one of the trappers seize
the horse by the bridle and spring into the saddle.
Frank gazed in surprise at these movements, but
before he could speak, the swarthy trapper turned
suddenly upon him, exclaiming:

"Look a here, stranger! Ye come here last
night without nobody's askin' ye, an' tells us some
kind of a story 'bout yer bein' lost, an' all that.
Now, mebbe yer all right, an' mebbe ye aint. Ye
may have friends no great way off, that ye kalker-
late to bring down on us; but ye can't ketch old
foxes like us in no sich trap as that ar'. We're
jest goin' to take yer hoss to keep yer from findin'
yer friends ag'in in a hurry. Yer young fur sich
bisness as this yere, an' if ye did n't look so mighty
innercent, I'd split yer wizzen fur ye. So now
be off to onct, an' do n't never cross our trail ag'in.
If ye do—" The trapper finished the sentence by
shaking his head threateningly.

Frank listened to this speech in utter bewilder-
ment. He could scarcely believe his ears. But it
was plain that the trappers were in earnest, for
the one who had mounted Pete held his own horse
by the bridle, in readiness to start. He fully re-
alized his helpless situation, and it almost over-

powered him. But, at length, he found courage
to say:

"You are certainly mistaken. I *am* lost. I
do n't know where to go to find my friends, and, if
you take my horse from me, I may never find them
again. Besides, what is your object in robbing
me?"

"Wal, now, stranger," said the trapper, drop
ping the butt of his rifle to the ground, and leaning
upon the muzzle of the weapon, "we jest aint a
goin' to stand no foolin'. We b'lieve yer a spy,
an' ar' goin' to bring Bob Kelly an' the rest of yer
friends down on us. That 's jest what 's the mat-
ter. The prairy is cl'ar, thar aint no Injuns to
massacree ye; ye have a good pair of legs, so trot
off on 'em to onct. Ye can be glad enough that
we did n't tie ye up to a tree, an' leave ye to the
wolves. If ole Kelly could get his hands on us,
we 'd be used a heap wusser nor robbin', an' you
know it well enough. An' when ye see the ole
chap, ye can tell him that the next time he wants
to try to ketch Black Bill, he 'll have to get up a
better trick nor this yere. Come, now, mizzle—
sally out to onct—an' do n't stop to talk, 'cause it
won't do no arthly good whatsomever. Yer hoss

ıs gone—that's settled—an', if yer shootin' iron
were any 'count, we'd a tuk that too. We've left
ye three loads, an' that'll kill game enough to do
ye till ye find yer friends. Come, walk off—make
yourself skeerce, sudden."

There was a wicked, determined look in the
trapper's eye that told Frank that he was in ear-
nest; and, fully convinced that it would be useless
to remonstrate, and fearful that if he did not obey
the order, the man would fulfill his threat of
tying him to a tree, and leaving him to the mercy
of the wolves, he shouldered his rifle, and, with a
heavy heart, set off on his journey.

When he reached the top of a high swell, about
half a mile from the camp, he looked back, and
saw the trappers riding off at a rapid gallop, Pete
playing and prancing with his new rider as if he
was perfectly satisfied with the change. Frank
watched them as long as they remained in sight,
and then, throwing himself on the ground, covered
his face with his hands, and gave away to the most
bitter thoughts. What could have induced the
trappers to act so treacherously? Did they really
suspect him of being a spy, or was that merely an
excuse to rob him in his defenseless situation?

The whole transaction was involved in a mystery he could not fathom, nor was it at all probable that he could arrive at a solution until he should see Dick or old Bob Kelly. Would he ever see them again, was a question he dare not ask himself. The chances were certainly not in his favor, situated as he was, alone, in the midst of an unbroken wilderness, the prairie stretching away, on one hand, as far as his eye could reach, the Rocky Mountains looming up on the other. But he was not one to look altogether upon the dark side of the picture. It had a bright side as well, and he found that he had reason to congratulate himself that the outlaws—for such he now knew them to be—had let him off so easily. What if they had left him bound to a tree, as they had threatened? The chances were not one in a hundred that he would ever have been released. Although his horse had been taken from him, he had been allowed to go free, and to retain his rifle and hunting-knife. Yes, his situation might have been infinitely worse. He still had much to be grateful for, and, as long as he had life, he would cherish the hope of being able to find his way to his friends As these thoughts passed through his mind, they

brought renewed strength and determination, and, rising to his feet, he again set out at a brisk walk.

He remembered that the outlaws had told him that, in order to reach the old bear's hole, he must travel in a direction exactly opposite to the one he was pursuing; but he had good reason to believe that they had endeavored to mislead him. When he took his involuntary ride, he was careful to remember the points of the compass, and, as Pete had carried him exactly south, of course, in order to reach his friends, he must travel north. He had no compass, but the sun was just rising, and he was able to calculate all the points from that. Having settled this to his satisfaction, he began an examination of his haversack, and found that its contents had been thoroughly overhauled—no doubt while he was asleep—and that the outlaws had left him three cartridges for his rifle, and his flint and steel. All the other articles, which consisted of several rounds of ammunition for his revolvers (which had gone off with his horse), stone arrow-heads, spear-heads, the claws of the bear that Dick had killed in the cave, and numerous other relics which Archie had collected since leaving St. Joseph, had all been abstracted.

In spite of his unpleasant situation, Frank could not repress a smile, when he thought how indignant his cousin would be, when he received an account of his losses. Having completed his examination, and placed his remaining cartridges carefully away in his pocket, he resumed his journey, and, just as he reached the top of a swell, he discovered a horseman galloping rapidly along the edge of the willows that fringed the base of the mountains. The thought that he saw something familiar, about both the horse and his rider, had scarcely passed through Frank's mind, when he was electrified by the sight of a large brindle dog, which ran in and out of the bushes, with his nose close to the ground, now and then uttering an impatient bark, which was answered by yells of encouragement from the horseman. There was no mistaking that yell, and Frank ran down the swell, swinging his hat, and endeavoring to attract the attention of the man with a voice which, in his excitement, he could scarcely raise above a whisper. But he was discovered. Both dog and horseman turned toward him, and, a moment afterward, Frank had one arm around the neck of Useless, and his hand was inclosed in the trapper's vice-like grasp.

CHAPTER XIV.

The Trader's Expedition.

"DICK," exclaimed Frank, as soon as he could speak, "this is the second time you have found me when lost; but I wish you had come a little sooner, for—"

"You keerless feller!" interrupted the trapper, who knew in a moment that there was something wrong, "you teetotally keerless feller! whar's your hoss? Tell me, to onct, what's come on him."

"He was stolen from me," answered Frank. "I camped last night about two miles from here, with a party of trappers, and they robbed me."

"Did!" exclaimed Dick. "Bar and buffaler! who war they? They war n't no trappers, I can tell ye, if they done that ar' mean trick. Tell me all about it to onct."

Frank then proceeded to relate all that had transpired at the camp; told how closely the men had questioned him concerning the intended movements of old Bob; repeated all the threats which the outlaw had made, and concluded his narrative with saying:

"He told me that when I saw old Bob again, l could say to him, that the next time he wanted to catch Black Bill, he—"

"Black Bill!" almost yelled the trapper. "Black Bill! That ar' tells the hul story. The scoundrel had better steer cl'ar of me an' old Bob, 'cause I'm Bob's chum now, an' any harm that's done to him is done to me too. I can tell you, you keerless feller, you oughter be mighty glad that you aint rubbed out altogether."

"I begin to think so too," replied Frank; "but, Dick, I want my horse."

"Wal, then, you'll have to wait till he comes to you, or till them ar' fellers git ready to fetch him back. 'Taint no 'arthly use to foller 'em, 'cause they'll be sartin to put a good stretch of country atween them an' ole Bob afore they stop. Your hoss ar' teetotally gone, youngster—that's as true as gospel. I tell you ag'in, 'taint every one that

Black Bill let's off so easy. Climb up behind me, an' let's travel back to the ole bar's hole."

Frank handed his rifle to his companion, mounted Sleepy Sam, and the trappers drove toward the camp, slowly and thoughtfully. For nearly an hour they rode along without speaking to each other. Dick, occasionally shaking his head and muttering "Bar an' buffaler—you *keerless* feller." But at length he straitened up in the saddle, and holding his heavy rifle at arm's length, exclaimed:

"Youngster, I do n't own much of this world's plunder, an' what's more, I never expect to. But what little I have got is of use to me, an' without it I should soon starve. But I'd give it all up sooner nor sleep in a camp with Black Bill an' his band of rascals. I'd fight 'em now if I should meet 'em, an' be glad of the chance; but thar's a heap of difference atween goin' under, in a fair skrimmage, an' bein' rubbed out while you ar' asleep. Durin' the forty year I've been knocked about, I've faced a'most every kind of danger from wild Injuns an' varmints, an' I never onct flinched—till I rid on them steam railroads—but, youngster, I would n't do what you done last night fur nothin'. Howsomever, the danger's all over now, an' you

have come out with a hul skin; so tell me what
you done while you war lost."

The manner in which the trapper spoke of the
danger through which he had passed, frightened
Frank exceedingly. He knew that Dick was as
brave as a man could possibly be, and the thought
that he had unconsciously exposed himself to peril
that the reckless trapper would shrink from en-
countering, occasioned feelings of terror, which
could not be quieted even by the knowledge that
he had passed the ordeal with safety; and when,
in compliance with the guide's request, he pro-
ceeded to relate his adventures, it was with a
trembling voice, that could not fail to attract the
trapper's attention.

"I do n't wonder you 're skeered," said he, as
Frank finished his story. "It would skeer a'most
any body. But it 's over, now, an' it aint no ways
likely you 'll ever meet 'em ag'in. Me an' ole Bob
will see 'em some day, an' when we settle with 'em,
we will be sartin to take out pay fur that hoss.
When we git to camp Bob 'll tell you how he hap-
pens to owe Black Bill a settlement. When we
seed you goin' off in that ar' way," continued the
trapper, turning around in his saddle so as to face

Frank, "we did n't feel no ways skeery 'bout your comin' back all right, if you got away from the buf-falers. Your uncle said, 'In course the boy has got sense enough to see that the mountains now ar' on his right hand, an' to know that when he wants to come back, he must keep them on his left hand;' an' jest afore he went to sleep, I heered him say to ole Bob, 'I wonder how Frank is gettin' on without his blanket.' Your little cousin said, 'I hope he 'll fetch back my rifle, an' my possible-sack, an' the things what 's in it, all right, 'cause I should hate to lose them Injun's top-knots. I guess he won't laugh none, when he finds out that all them stone arrer-heads, an' spear-heads, an' other fixin's ar' gone.' Ole Bob, he knowed, too, that you would turn up all right if you could keep on your hoss till he stopped. But, bar and buffaler! we did n't think you war goin' to camp with that var-let, Black Bill. If we had, thar would n't have been much sleepin' done in our camp last night."

Having thus assured Frank that his friends had entertained no fears of his ability to find his way back to the wagon, the trapper again alluded to the subject of the robbery, obliging his young companion to relate the particulars over and over

again, each time expressing his astonishment and indignation in no very measured terms. In this way they passed the fifteen miles that lay between them and the camp, and finally arrived within sight of the "ole bar's hole."

Mr. Winters, Archie, and Bob were seated on the ground near the wagon, but when they discovered the trapper riding toward them with Frank mounted behind him, they rose to their feet in surprise, and Archie inquired, as he grasped his cousin's hand—

"Did your horse run himself to death?

Before Frank could answer, Dick sprang from the saddle, exclaiming:

"Bob! Black Bill's on the prairy."

"Black Bill on the prairy!" repeated the old man, slowly, regarding his friend as if he was hardly prepared to believe what he had heard.

"Yes, he ar' on this yere very prairy," replied Dick; "an', Bob," he continued, stretching his brawny arms to their fullest extent in front of him, and clenching his huge fists, "an', Bob, that ar' keerless feller actooally camped with him an' his rascally chums, last night. Yes, sir, staid in their camp an' slept thar, an' this mornin' they said as

how he war a spy of your'n, sent to ketch 'em; so they stole his hoss."

Old Bob was so astonished at this intelligence, that he almost leaped from the ground; while Dick, without allowing the excited listeners an opportunity to ask a question, seated himself beside Mr. Winters and proceeded to give a full account of all that had transpired at Black Bill's camp; during which, Archie, surprised and indignant at the treatment his cousin had received, learned that he also had been a heavy loser by the operation. All his beloved relics were gone. But they still had miles of Indian country to traverse, and these could be replaced; while Frank, in being robbed of his horse had sustained a loss that could not be made good. Archie was generous; and, declaring that he had ridden on horseback until he was actually tired of it, told his cousin to consider Sleepy Sam as his own property, an offer which the latter emphatically refused to accept.

"Never mind, youngster," said old Bob, who had listened to all that had passed between the cousins, "never mind. You shan't lose nothin' by bein' robbed by that varlet. Me an' Dick will put you on hossback ag'in afore you're two days older.

12

But this yere shows you that you ought n't to make
friends with every feller you meet on the prairy,
no more 'n you would in a big city. Now if you
war lost in the settlements, and did n't know whar
to go to find your hum, you would think twice afore
you would camp with a teetotal stranger, an' a fel-
ler oughter do the same thing on the prairy. I
larnt that long ago, an' through that same feller,
Black Bill. Years ago, when Dick's old man war
alive, it war n't so. If a feller got a leetle out of
his reckonin', an' walked into a stranger's camp,
he could roll himself up in his blanket an' sleep as
safe an' sound as he could any whar, an' neither
man war n't afraid that the other would rub him
out afore daylight. But it aint so now. Them
fellers in the settlements got to doin' meanness, an'
run here to git cl'ar of the laws. But they found
thar war law here too; an' when they done any
of their badness, an' we got our hands on 'em, we
made short work with 'em. But they kept comin'
in fast, and when three or four of 'em got together,
they would take to the mountains, an' thar war n't
no use tryin' to ketch 'em. When we seed how
things war agoin', a lot of us ole trappers, that
had knowed each other fur years, made up a

comp'ny. We had to do it to defend ourselves ag'in them varlets, fur it soon got so it war n't healthy fur a lone man on the prairy, if he had any plunder wuth baggin'. We stuck together till that Saskatchewan scrape, an' now me an' Dick ar' the only ones left. I do n't say that we 're the only honest trappers agoin', 'cause that aint so. Thar ar' plenty of good ones left; but we ar' the last of our comp'ny, an', somehow, we do n't keer 'bout trappin' with strangers.

"Wal, one spring we went to the fort to trade off the spelter we had ketched durin' the winter, an' the trader we sold 'em to, war makin' up a comp'ny to go to the head waters of the Missouri. He war goin' with his expedition, an' he wanted us to go too. He offered us good pay; he would find us we'pons, hosses, traps, and provender fur nothin', an' buy our furs to boot. He done this 'cause thar war a good many traders workin' ag'in him, an' he wanted to be sartin of gittin' all the furs we trapped. We had a leetle talk among ourselves about it, an', finally, told him that it war a bargain, an' that we would go. So he writ down our names, an' we tuk up our quarters in the fort till the day come to start. The trader's name war Forbes, an'

as he war our boss, we used to call him Cap'n
Forbes. He war n't jest the kind of a man a feller
would take to be a trader—he smelt too much of
the settlements—an' even at the fort, among rough
trappers an' soldiers, he would spruce up an' strut
like a turkey. 'Sides, he had a nigger to wait on
him an' take keer of his hoss. As I war sayin',
we noticed all these things, but we did n't keer fur
'em, fur, in course, it war n't none of our consarn ;
all we wanted war fur him to pay us fur the spelter
we ketched, an' we knowed he could do that, fur
the fellers all said he had a big pile of gold an'
silver that he carried in his saddle-bags.

"Wal, we packed our blankets an' we'pons down
to the quarters the cap'n pointed out, an' when we
got thar, we found he had half a dozen chaps down
'sides ourselves. We knowed one or two of 'em, (an'
we did n't know nothin' good of 'em neither,) but the
others war strangers to us. Among the strangers
war Black Bill—Bosh Peters he said his name war.
He war a'most as black as the cap'n's darkey, an'
thar war a bad look in his eye that none of us
did n't like. An' him an' his crowd war n't at all
pleased to see us neither ; fur, although they met
us kind enough, asked us to help ourselves to their

grub, an' inquired 'bout our luck in trappin', durin' the last season, thar war somethin' 'bout them that told us plainer nor words that they would have been much better satisfied if we had stayed away

"It war a'most night when we went to the quarters, an' arter we had eat our supper, we smoked our pipes, spread our blankets, an' went to sleep. How long I slept I do n't know; but I waked up sometime durin' the night, an' thought I heered somebody talkin' in a low voice. I listened, an', sure enough, thar war two fellers jest outside of the quarters plannin' somethin'. I heered one of 'em ask :

"'When shall we do it?'

"'Time enough to think of that when we git to the mountains,' said the other.

"'But ar' you sartin' he's goin' to take it with him ?'

"'In course! I heered him say so !'

"'Wal, then, it's all right. But we must be mighty keerful, 'cause our boys do n't like the looks of them last fellers that jined the comp'ny. So keep a still tongue in your head.' They done some more plannin' and talkin', but I could n't hear what it war. Then they moved away in

different directions, an' purty quick somebody come
into the quarters, easy like, an' laid down on his
blanket, but it war so dark I could n't see who it
war. Wal, I thought the matter all over, an' soon
made up my mind that the varlets had been plan-
nin' an' talkin' ag'in the trader and his money-
bags; but when I told the boys of it the next
mornin', they all laughed at me, an' said the cap'n
war n't fool enough to tote so much money to the
mountains with him when he could leave it at the
fort, whar it would be safe. They told me I had
better not speak of it ag'in, fur if it got to the
trader's ears, he might think I war a greeny. Wal,
I war quite a youngster, that's a fact; but it
war n't long afore it come out that I had more
sense nor any of 'em."

CHAPTER XV.

The Outlaw's Escape.

"EFORE goin' further," continued the trapper, "I oughter tell you that this Black Bill had been on the prairy a long time. Like a good many others, he had run away from the law in the States, an', fallin' in with more rascals as bad as he war, he soon made himself known, by name, to nearly every trapper in the country. 'Sides robbin' lone men he met on the prairy an' in the mountains, he would jine in with Injuns, an' lead 'em ag'in wagon trains.

"None of our comp'ny had ever seed him, although, in course, we had often heered of him, an' we never onct thought that he would have the face to jine in with a party of honest trappers; so we called him Peters, bein' very fur from thinkin' that he war the feller that had done so much mischief.

If we *had* knowed who he war, prairy law would n'i
have let him live five minits.

"Wal, arter we had been at the fort 'bout two
weeks, Cap'n Forbes got every thing ready fur the
start, an', one mornin', bright an' 'arly, we sot off
t'wards the mountains. Thar war fourteen of us
altogether—seven of us fellers, five of Bosh Peters'
party, the trader, and his darkey. We had four
pack mules; and, as the Cap'n war n't a bit stingy,
he had give us good we'pons an' plenty of powder
an' lead. I had n't forgot what them two fellers
said that night, although I had n't never spoke
about it, fur fear of bein' laughed at—an' I kept
close watch on the trader, to find out if he had his
money with him. He carried a pair of saddle-
bags, an' they were well packed, too; but, judgin'
by the keerless way he throwed them around, when
we camped fur the night, thar war n't no money in
'em. Bosh Peters and his party had all along
been tryin' to git on the right side of us, and purty
soon our fellers begun to think that we had been
fooled in 'em, an' that they war all right arter all.

"Wal, when we reached the trappin' grounds,
we built our quarters fur the winter, an' then com-
menced work. The trader went with one feller

one day, an' with another the next. He war n't
no trapper; but he liked the sport, an' seemed to
want to larn how it war done. But, arter awhile
he got tired of this, an' staid in the camp from
mornin' till night. He never went out with me;
if he had, I should have told him to keep his eye
on them money-bags, if he had 'em with him.

"One day, as I war at work settin' a trap in a
clump of bushes that grew on the banks of a little
creek, I heered some fellers comin' along, talkin' to
each other. Now, jest that one little thing war
enough to make me b'lieve that thar war some-
thin' wrong in the wind, 'cause, when fellers go
out to hunt an' trap, an' fur nothin' else, they
do n't go together through the woods, as though
they were huntin' cows. So I sot still an' listened,
an' purty quick heered Bosh Peters talkin'. Thar
war one feller with him, but the bushes war so
thick I could n't see him, an' I did n't know his
voice. They war comin' right t'wards me, an'
when they reached the creek, one of 'em went to
get a drink, an' the others sot down on a log not
ten foot from me. Purty soon I heered Bosh Pe-
ters say:

"'I know it's time we war doin' somethin'

Tom, but I'm a'most afraid to try it. Them 'ar
fellers are seven to our five, an' if we should n't
happen to get away, we would ketch prairy law,
sartin ; an' that's a heap wusser nor law in the
settlements. They do n't give a feller a chance to
break jail on the prairy.'

" 'Black Bill,' said the other, ' thar's jest no
use a talkin that 'ar way. If we're a goin' to do
it at all, now is jest as good a chance as we shall
have. The cap'n stays in the camp all day alone,
an' afore the other chaps get back to larn what's
done, we can be miles in the mountains.'

" ' Wal, then,' said Black Bill, 'let's do the job
to onet. The cap'n war in the camp this mornin'
when I left, an' if he's thar this arternoon, we 'll
finish him, an' the money-bags are ourn. But
let's move off; it won't do fur us to be seed to-
gether.'

" The varlets walked away, an' I lay thar in
them bushes fifteen minutes afore I stirred. This
war the fust time that I knowed Black Bill war
one of our comp'ny. To say that I war surprised
to hear it, would n't half tell how I felt. I war
teetotally tuk back. The idee of that feller com-
in into our camp, when he knowed that if he war

found out, short work would be made with him!
I could hardly b'lieve it. But I could n't lay
thar, foolin' away time with such thoughts, when
I knowed that the cap'n's life war in danger. So,
thinkin' the rascals had got out of sight an' hear-
in', I crawled out of the bushes, intendin' to start
at onct fur the camp, an' tell the fellers what I
had jest heered. I walked down to the creek fust,
to get a drink, an' jest as I war bendin' over, I
heered the crack of a rifle; a bullet whistled by,
not half an inch from my head, an' buried itself
in the ground. I jumped to my feet, an' lookin'
up the bank, saw a leetle smoke risin' from behind
a log not twenty yards distant. Grabbin' my
rifle, which I had laid down as I war goin' to
drink, I rushed acrost the creek, an' the next
minit war standin' face to face with Black Bill.
Fur an instant the chap shook like a leaf, an'
turned as pale as his black skin would let him.
Then he seemed to find his wits ag'in, fur he stuck
out his hand, sayin':

"'By gum, Bob Kelly! is that you? I'll be
shot if I did n't take you fur an Injun. I'm
mighty glad I did n't hit you, Bob!'

"'You can 't blarney me, Black Bill,' said I.

'I know you;' an' as I stood thar lookin' at the ras-
cal, an' thought of all the badness he had done, I
had half a mind to shoot him. The way of it
war, the varlet kind o' thought that somebody
had been listenin' to what he said 'bout robbin'
the cap'n, an' he had hid behind the log to watch.
When he seed me come out of the bushes, he
knowed that I had heered all that had been goin'
on, an' he thought his best plan war to leave me
thar dead. But, although he war n't twenty yards
off when he fired at me, he missed me teetotally.
Wal, when he seed that I knowed him, an' that
he could n't fool me into b'lievin' that he tuk me
fur an Injun, he thought he would skeer me, so
he growled :

"'If you know me, Bob Kelly, you know a
man that won't stand no nonsense. I have friends
not fur off, an' if you know any thing, you 'll travel
on 'bout your own bisness.'

"'Now, look a here, Black Bill,' said I, 'I
haint never been in the habit of standin' much
nonsense, neither—leastways not from such fel-
lers as you, an' if you knowed me, you would
know that I do n't skeer wuth a charge of gun-
powder. That 'ar is the way to the camp, an'

if you want to live two minutes longer, you'll travel off to onct.' Seein' that he didn't start, but that he stood eyein' me as if he'd a good mind to walk into me, I stepped back, an' p'intin' my rifle straight at his heart, said : 'I shan't tell you more'n onct more that 'ar is the way to camp. You can go thar, or you can stay here fur the wolves, jest as you please.'

"I guess he seed that I war in 'arnest, fur he shouldered his empty rifle, an' started through the woods, I follerin' close behind, ready to drop him if he should run or show fight. I felt mighty on-easy while travelin' through that timber, 'cause I knowed well enough that the rascal had friends, an' if one of 'em should happen to see me march-in' Black Bill off that 'ar way, he'd drop me, sar-tin. But I reached the camp in safety, an' thar I found two of our own fellers, an' four that I had allers thought war friends of Black Bill. They all jumped up as we came in, fur they knowed by the way I looked that somethin' war wrong, an' one of 'em said:

"'What's Bosh Peters been a doin', Bob?'

"'That aint no Bosh Peters,' said I; 'that 'ar chap is Black Bill.'

"Now comes the funniest part of the hul bis-
ness. Every trapper on the prairy, as I told you,
had heered of Black Bill, an' when I told 'em that
my prisoner war the very chap, an' that he had
been layin' a plan to rob the cap'n, I never seed
sich a mad set of men in my life.

"They all sot up a yell, an' one of 'em, that I
would have swore war a friend of Black Bill,
drawed his knife, an' made at the varlet as if he war
goin' to rub him out to onct. But my chum, Ned
Roberts, ketched him, and tuk the we'pon away
from him. This sot the feller to bilin', and he
rushed round the camp wusser nor a crazy man.
He said that Black Bill had shot his chum, an' that
he war swore to kill him wherever he found him;
and he war goin' to do it, too. An' the fust thing
we knowed, he grabbed somebody's rifle, an'
jumped back to shoot the pris'ner. But he war
ketched ag'in, afore he could fire, and then he
howled wusser nor ever. Wal, we tied Black Bill
to a tree in the camp, an' this feller kept slippin'
round, with his tomahawk in his hand, an' it tuk
two men to get the we'pon away from him.

"The chap tuk on so, that we all thought that
he told the truth, but, (would you believe it?) I

arterwards larnt that he war the very same chap
that I had heered talkin' with Black Bill 'bout rob-
bin' the cap'n. He kind o' thought that we might
know something ag'in him, an' he carried on in that
way to make us b'lieve that he war really an en-
emy of Black Bill. In course we did n't know this
at the time. If we had, he'd soon been a pris'ner
too. But, supposin' him to be tellin' the gospel
truth, we felt sorry fur him, an' promised that
Black Bill should n't ever be let loose to do mean-
ness ag'in. While the fuss war goin on, the trader
come out; an' when we told him what happened—
how the pris'ner an' one of his friends, that we
did n't know, had been layin' a plan to do robbery
an' killin'; an' that the chap he called Bosh Pe-
ters war none other than Black Bill the outlaw—I
never seed a man so tuk back in my life. It
skeered him purty bad. He had allers looked
upon Black Bill as one of the honestest men in
the expedition; an', when he found that he war a
traitor, he did n't know who to trust; an' he tuk
mighty good keer not to be alone durin' the rest
of the arternoon.

"Wal, when it growed dark, the fellers began to
come in from their day's work, some loaded with

furs, an' others with a piece of bar or big-horn, which they had knocked over for supper. As fast as they come in, we told 'em what war up, an' they did n't take it very easy, now, I tell you.

"The idee that Black Bill, arter doin' so much badness—robbin' lone trappers an' leadin' wild Injuns ag'in wagon trains—should come into one of our forts, an' stick his name down with those of honest, hard-workin' trappers, when he knowed that every one of 'em had plenty ag'in him, I say it war hard to b'lieve. But thar he war, tied to a tree, an', when the boys come to look at him close, they wondered that they had n't knowed afore that he war a villain.

"Wal, we waited a long time for all of our fellers to come in; but thar war three of us missin', an' that war the only thing that saved Black Bill. We did n't want to pass sentence on him without lettin' all the boys have a chance to say somethin'; an' as they might come in some time durin' the night, we thought we would keep the varlet till mornin'. So we tied him, hand an' foot, and laid him away in one of the cabins. The cap'n's darkey made him a bed of hemlock boughs, an' laid him on it, abusin' him all the while like all natur',

an' goin' in for shootin' him to onct. It would
have been well for one of us, if we had put that
darkey in there as a pris'ner too. But we didn't
know it, an' afore we got through he cost us the
life of one of the best men in our comp'ny. The
fellers then all went to bed except me. I guarded
the varlet till the moon went down, and then, arter
calling my chum, who war to watch him till day-
light, I went into my quarters an' slept soundly
all the rest of the night. When it come mornin',
I awoke, an', in a few minits, all our boys war up.
The fellers had all come in durin' the night, an' ole
Jim Roberts—my chum's ole man—who war our
leader, called a council. Black Bill didn't seem
to have a friend among us, for the last man of us
said as how the law must be lived up to.

"'Who guarded him last night?' asked the ole
man.

"'I did,' I answered, 'till the moon went down,
and then Ned tuk my place.'

"'Wal, Ned, bring out the pris'ner,' said the ole
man. 'But whar is Ned?' he asked, runnin' his
eye over the camp. 'Ned! Ned Roberts!'

"I had all along s'posed that Ned war still
guardin' the pris'ner; but when he didn't answer,
13

I knowed in a minit that somethin' had been goin' wrong ag'in, an' the others knowed it too, fur men who have lived in danger all their lives aint long in seein' through a thing of that kind. So we all rushed to the cabin where we had left the outlaw, an' there lay my chum—stark an' dead—stabbed to the heart! The pris'ner war gone. Thar war the strips of hickory bark we had tied him with, an' thar war the knife he had used—but Black Bill had tuk himself safe off. We stood thar, not knowin' what to say or do. Ole Jim war the fust that could speak.

"'Another gone,' said he; 'an' it's my only son; an' now whar's the traitor?'

"He looked from one to the other of us as he said this, but no one answered.

"'He's here right among you,' said the ole man, the tears rollin' down his cheeks. 'He's right among you. That knife couldn't got in here without hands; an' thar's somebody in this yere camp, that's helped Black Bill in makin' his escape. Speak, men, who's the outlaw's friend?'

"But still no one answered. We all knowed he war thar, but how could we tell who it war, when we had no proff ag'in any one?

" 'Bring him out, boys,' said the old man, at last. 'He war a kind son, an' a good trapper. But he 's done his work now, an' we 've lost one of the best men in our comp'ny.'

"Wal, we carried poor Ned out, an' arter layin' him in my cabin, we started off on the trail of the outlaw. But he had a good long start, an' that night we had to come back without him. I 've never seen him from that day to this.

"The next mornin' none of us went out to trap, fur we could n't help thinkin' of poor Ned. He war the fust chum I had ever had, an' me an' him had been together a'most ever since we had strength to shoulder a rifle—more 'n ten year— an', in course, I war in natur' bound to avenge him. I staid in my quarters, wonderin' who it war that had helped the outlaw; when, all of a sudden, I happened to think of somethin' that brought me to my feet in a hurry, an' sent me into ole Jim's quarters. I talked the matter over with him, told him what I thought, an', in a few minits more, we called our boys together, an' war marchin' t'wards the trader's camp. The darkey war cookin' his master's breakfast, in front of the cabin, singin' an' whistlin' as jolly as could be; but when he

seed us a comin' he shet up in a mighty hurry,
an' actooally turned white! I knowed he wouldn't
act that ar' way if he warn't guilty, so I sung out,
'Here's the traitor, boys!'

"The darkey, seein' that the thing war out, start-
ed to run. He hadn't gone far, howsomever, afore
we had him, an' then he 'fessed the hul bisness.
He said he had told the outlaw that the cap'n
war goin' to take his money-bags with him, an'
that, bein' the last to leave Black Bill arter we had
tied him, he had hid the knife in his bed. The
pris'ners arms had been fastened above his elbows,
an', in course, havin' a sharp we'pon, it war the
easiest thing in the world to cut himself loose, an'
to pitch into poor Ned afore he knowed it. Arter
he had 'fessed this, we held a council, an' prairy
law tuk its course. This skeered the trader wusser
nor ever. If his own servant war treacherous, he
couldn't trust nobody. So he ordered us to break
up our camp an' strike fur the fort. When we got
thar, an' offered to give up our hosses an' we'pons,
he wouldn't listen to it at all. He said that we
had saved him an' his money-bags, an' that we
could keep our kit, an' welcome.

"Wal, our huntin' expedition bein' broke up, we

put out on our own hook. We still thought that
them four fellers b'longed to Black Bill's party, an'
we soon found that it war so; fur we had hardly got
out of sight, afore they started fur the mountains.
They knowed 'bout whar to go to find the outlaw,
an' they 've been with him ever since, robbin' an'
stealin'. One of his party has been rubbed out,
but thar ar' four of them left yet, an' they do a
heap of mischief. I have looked an' watched fur
'em fur years, an' if I never find 'em, I shall leave
'em to Dick; so I know justice will be done 'em.
If you had knowed all these things, youngster, I
do n't reckon you would have slept very sound in
Black Bill's camp."

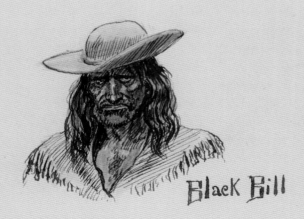

Black Bill

CHAPTER XVI.

The King of the Drove.

THE travelers had been intensely inter-
ested in the old trapper's story, and
not even the thought that the danger
was passed, and that Frank was safe in
camp again, could altogether quiet their
feelings. Frank was more astonished
than ever, and he secretly determined
that he would never again lose sight of the wagon,
if he could avoid it. But, if he should again be
compelled to take an involuntary ride, and should
happen to fall in with strangers on the prairie, he
would give them a wide berth.

Mr. Winters said nothing. He did not think
that the occasion demanded that he should caution
his nephew, for it was by no means probable that
the latter would soon forget his night in the out-
law's camp.

His adventures, which were the subject of a lengthy conversation, did not, however, entirely quench his love of excitement, and when, after a hearty dinner on buffalo hump, Archie proposed a short ride on the prairie, he agreed to accompany him, and, as soon as he had caught and saddled his uncle's horse, was ready for the start. As they rode along out of the woods, Archie informed his cousin that another herd of buffaloes had been seen that morning by old Bob, feeding near the base of the mountains, and announced his determination of endeavoring to shoot one, if they should happen to come across them. As there was now no danger of being stampeded—both of their horses being old buffalo hunters—Frank agreed to the proposal, and followed his cousin, who led the way toward the place where the buffaloes had last been seen. Swell after swell they mounted, straining their eyes in every direction, without discovering the wished-for game.

But they saw something else that excited them quite as much as the sight of a herd of buffaloes would have done; for, as Archie, who had ridden some distance in advance of his cousin, reached the top of one of the hills, Frank saw him suddenly

draw rein, and back his horse down the swell, out
of sight of something which he had discovered on
the other side. He then rode back to meet Frank,
and, as soon as he came within speaking distance,
whispered, excitedly:

"There's a big drove of wild horses out there."

Frank waited to hear no more, but, throwing his
bridle to his cousin, dismounted from his horse,
and, going cautiously to the top of the swell, looked
over. Sure enough, there they were, about half a
mile distant, probably five hundred of them, scat-
tered about over the prairie, some feeding, and
others prancing about, as if wholly unconscious of
danger. Among them was one horse—an iron-
gray—rendered conspicuous by his great size and
extraordinary beauty, which galloped about as if
he were "monarch of all he surveyed." Frank
remembered what Dick had told him about every
drove of wild horses having a "master," and, as
he watched his movements, and noticed how the
other horses shied at his approach, he came to the
conclusion that the gray horse was the king. He
gazed at them for some time, admiring their rapid,
graceful movements, and thinking how fully the
gray would supply the place of the horse he had

lost, when he noticed that the animals were feeding directly toward him. Fearful of being discovered, he crawled back down the swell, and rejoined his cousin.

"What shall we do?" asked the latter, excitedly.

"Don't you suppose Dick could catch one of those fellows?" inquired Frank.

"Of course he could," answered Archie, quickly. "Didn't he catch that black mustang he told us about—a horse that every body had tried to catch, and couldn't? Let's go back, and ask him to try."

The boys hastily remounted, and started for the camp as fast as their horses could carry them. Archie, of course, led the way, and, as he dashed up to the wagon, he threw himself from the saddle, exclaiming:

"Dick, there's a drove of wild horses out there on the prairie. Jump on Sam, and go and catch one for Frank."

"That's the same drove I seed day afore yesterday," said old Bob, "an' that's what I meant when I told Frank we'd put him on hossback ag'in afore he war two days older. Ketch my hoss, Dick."

Dick did as he was desired, and, by this time, Frank had come up, Archie, in his eagerness, having left him far behind.

"Did you skeer 'em, youngsters?" asked old Bob, as he went to the wagon and drew out two rawhide lassos, one of which he handed to Dick.

"No," replied Frank. "They did n't see us. Dick, catch the king—he 's a large iron-gray—the prettiest horse in the drove. If I could have him, I would be glad I lost Pete."

"Wal, now, that ar' will be a hard thing to do, youngsters," replied the trapper, coiling up his lasso, and hanging it on the horn of his saddle; "a mighty hard thing to do. Them ar' kings ar' allers the swiftest hosses in the drove; an' it aint every ole buffaler hunter that can keep up with 'em."

Archie was astonished to hear the trapper speak so lightly of Sleepy Sam, a horse that had several times proved himself to be possessed of great speed; but Dick hastened to explain.

"I aint sayin' nothin' ag'in your hoss, little one, no more 'n I am ag'in Bob's. But if you had chased wild hosses as often as I have, you would know that a hoss can beat any thing in a wagon

train, an' yet have no bisness with the king of a
drove. I wo n't say that we 'll ketch that gray fur
you, Frank, but we 'll try hard, an' if he is too fast
fur us, we 'll lasso one of the others, sartin. We 'll
bring back somethin' fur you to ride."

By this time the trappers were ready for the
start. Mr. Winters and the boys accompanied
them to the edge of the prairie, and there Bob and
Dick left them, after repeatedly assuring Frank
that it was not their intention to return empty-
handed.

When they had disappeared, Mr. Winters and
the boys seated themselves on the ground, and for
nearly an hour, waited and listened for the sound
of the pursuit. Suddenly a single horse appeared
upon the summit of a distant swell, and facing
about, stood as if regarding some object that had
excited his curiosity. Then came another, and
another, and in a moment more the entire drove
appeared, running at the top of their speed. One
minute elapsed—two—three—and then two more
horses suddenly arose over the swell, and followed
swiftly after the drove. The chase had begun in
earnest. The boys were surprised, and not a little
discouraged, to see the trappers so far behind. But

still they had great confidence in them, and Frank was already reconciled to the loss of his horse, and confident that he would own another before he went to sleep that night. The chase was tending directly toward the mountains, and it presented a sight the boys would have been loth to miss. Nearer and nearer came the wild steeds, prancing and snorting, and looking back at the strange objects that were pursuing them. Presently, among the foremost ones, the boys discovered the gray king. He moved over the ground as lightly as if he had been furnished with wings, and as Frank watched his movements, he reluctantly came to the conclusion that if his endurance was as great as his speed, he must content himself with one of the common horses of the drove. They continued to advance until they came within a quarter of a mile of the willows, when they seemed, for the first time, to discover that their retreat in that direction was cut off by the mountains. This appeared to confuse and frighten them. The foremost ones slackened their speed, but seeing their pursuers close behind them, the drove suddenly divided, part of the horses turning one way, and the rest going the other. The trap

pers had kept their eyes on the king, and, when he turned, they singled him out from the others, and followed him with increased speed. The gray mustang made an exhibition of his powers that was truly surprising; but the trappers took a "short cut" on him, and gained so rapidly that Frank's hopes rose again. Sleepy Sam was running splendidly; but, to the surprise of all, old Bob's ungainly, raw-boned horse, in answer to a yell from his rider, bounded past him. All this happened in much less time than we have taken to describe it. The horses moved with wonderful rapidity, and, in a very few moments after the drove divided, the gray king and the trappers were out of sight behind the swells, and all sounds of the chase had died away in the distance.

Mr. Winters then returned to the camp, while the excited boys again seated themselves on the ground, and waited long and impatiently for the trapper's return. The hours slowly wore away, and, finally, the sun went down, but still no signs of the horsemen. It soon began to grow dark, and the boys were obliged to return to the wagon. Frank prepared supper that evening, but their appetites must have gone off with the gray mustang, for they ate

but little. They sat beside the fire until midnight, straining their ears to catch the first sounds of the trapper's return; but nothing but the occasional howl of a wolf broke the stillness; and, finally, growing tired of watching, they spread their blankets and went to sleep. At the first peep of day they were again stirring, and, after a hasty breakfast, they stationed themselves in the edge of the willows, to await the return of the horsemen. In about two hours their patience was rewarded by the discovery of several objects moving along the summit of a distant swell. As they approached, the boys recognized the trappers, and in half an hour they were within speaking distance. Could Frank believe his eyes? Was Dick really riding the gray king? It was a horse that bore a strong resemblance to him, and Frank felt confident that the animal he had so much admired, was really his own. Nor was he deceived; for, as they came up, Dick exclaimed:

"Here we ar', youngsters. We've got him, sure as shootin'. Easy thar," he continued, as the delighted boys walked slowly around him, admiring his fine points. "If you know any thing you'll keep cl'ar of his heels. He aint very good natur'd.'

This was very evident; for the trapper had scarcely spoken before the mustang began to show his temper. He danced about in the most lively manner; first rearing up almost straight in the air, and then kicking with both hind feet. His plunges were furious and desperate, and the boys fully expected to see the trapper unseated. But the latter, although he had no saddle — that being a contrivance he despised—and only had his lasso twisted around the gray's lower jaw, for a bridle, kept the animal completely under his control, and rode him into the camp in triumph.

"The critter led us 'bout as long an' as lively a race as we ever run," said Dick, after the gray had been securely fastened to a tree. "An' it war only by accident that we ketched him. I do n't reckon I am sayin' too much when I say that I never seed a hoss run faster nor hold out better nor he did—not even the black mustang. "We went 'round on the other side of the drove afore we started 'em, on purpose to make 'em run t'wards the mountains. That give you a good sight of somethin' you never seed afore, an' by it we gained on the gray when he turned. Wal, he kept ahead of us for ten or twelve miles, gainin'

on us all the while, fur when he seed that we war
arter him in 'arnest, the way he did climb over the
prairy war a purty thing to look at—when, all to
onct, we found ourselves in a prairy-dog's nest.
The prairy, as far as a feller could see, war like
a honey-comb. I 'spected every minit that my
hoss would break through, an' at last he did. But
the gray broke in fust—went down clean to the
top of his legs, an' could n't git out. I war sartin
we had him, an' war jest goin' to throw my lasso,
when my hoss went in, an' kerchunk I went on the
ground. But ole Bob war on hand, an' he ketched
him. We told you, Frank, that we'd put you on
horseback ag'in, an' now that we've done it, I
do n't reckon you'll lose this animal by campin'
with Black Bill."

CHAPTER XVII.

How the Trapper got his Horse.

FTER supper, the travelers seated themselves around the fire, and the trappers lighted their pipes. After smoking awhile in silence, old Bob said:

"As I have told you afore, young-sters, it aint always a easy job to lasso the king of a drove of wild hosses. The runnin' we done to-day arter the gray war n't nothin' to what we kalkerlated to do when we left here; an' if he had n't got into that prairy-dogs' nest, thar 's no knowin' how many miles he would a been from here by this time. When I war a youngster, I went to the Saskatchewan fur the fust time, with a party of six trappers—Dick's ole man war one of 'em—an', being keerless, like all young fellers, I soon made away with one of the

14

best hosses I ever owned. I run him clean blind
arter a herd of buffaler. I soon got another, how-
somever, but it war n't as good a one as I wanted;
an' I begun to look around to find a critter that
suited me. One day I come acrost a drove of
wild hosses, an', arter foolin' round them fur awhile,
I diskivered that they war led by a chestnut-col-
ored critter—a purty feller—an' I made up my
mind that he war just the one I wanted. I had
never ketched a wild hoss then, an' I had heered
enough about them to know that them kings ar'
allers the best animals in the drove, an' that it
takes a hoss as *is* a hoss to keep up with one of
'em. But I could throw the lasso tolible sharp,
an' war jest 'bout that age when youngsters think
they know more 'n any body else on 'arth; so I
thought I could ketch him easy. Wal, I dodged
round them till I got within 'bout half a mile of
'em, and then put out arter the king; but, human
natur, how he did run! I follered him 'bout
four mile, and then turned t'ward the camp, thinkin'
that mebbe thar war a few things I did n't know
nothin' at all 'bout. Some days arterward, I seed
him ag'in; but he run away from me easy, an' I
went back to the camp to be laughed at fur my

trouble. But I knowed that I should have plenty
of chances to ketch him afore we started fur hum—
we war to stay thar till spring—so I said nothin',
but kept lookin' round, an' every time I seed the
chestnut king, me an' him had a race.

"I got him at last—not in the way I expected,
howsomever—an', to make the story plain, I must
tell you what happened 'bout three year afore that.

"I war born on the banks of the Missouri River,
'bout twenty mile from whar St. Joseph now stands.
It war thar my ole man fust larnt me how to handle
a rifle an' ride a wild mustang. Thar war a fort
'bout a mile from our cabin, whar the ole man
allers went to sell his furs. It war n't no ways
safe thar, in them days, fur all that country b'longed
to the Injuns, who war n't very friendly t'ward
white settlers. But, whenever thar war any
trouble, we had a safe place to go to, an' onct,
when I war only twelve year ole, I stood 'side my
ole man, in the fort, an' helped drive off atween
four an' five hundred red-skins. I done so well
that ole hunters an' trappers slapped me on the
back, sayin' that I war a 'chip o' the ole block,'
and that I'd be a better Injun-hunter nor my
father some day. This pleased my ole man, an'

when the Injuns had gone, he took me on a trap-
pin' expedition with him. Thar war four of us,
an' we war gone all winter. I ketched my share
of the furs, an' killed two grizzly bars, which war
something for a chap of my years to brag on.
Wal, we reached hum in the spring, an', arter I
had stayed at our cabin two or three days, tellin'
my mother big stories of what I had seed, an'
what I had done, the ole man sent me down to
the fort to trade off our spelter. I ought to say
that on our way hum we had dodged a large party
of Injuns that war on a scalpin' expedition. They
had been off a fightin' with another tribe, an', hav-
in' got thrashed, they war n't in very good humor.
I war afraid they might take it into their heads to
visit the country 'round the fort, an' massacree the
settlers; but the ole man laughed at me, an' told
me to go 'long 'bout my bisness, an' sell them furs.
So, as I war sayin', I sot out fur the fort, an',
while I war makin' a bargain with the trader, a
trapper came in on a hoss that war a'most ready
to drop, an' said that the Injuns war strikin' fur the
fort. I do n't reckon that they intended to come
afore night; but this trapper had got away from
'em, an', knowin that he would alarm the settlers

the Injuns jest thought they would make a rush, an' massacree men, women, an' children, afore they could reach the fort.

"Wal, I did n't wait to hear no more; but, grabbin' up my we'pons, started fur hum arter the old folks. Purty quick I heered a firin' an' yellin', an' made up my mind that them as did n't reach the fort in less nor ten minits would be goners, sartin, fur the Injuns war comin', sure enough. A little further on I met my mother, who told me that the ole man an' a few more of the settlers war fightin' back the Injuns to give the women an' young ones time to git safe under kiver. My mother war a'most too ole to walk so fur, so I took her on my hoss, and carried her t'wards the fort, intendin' that as soon as I had seed her safe I would come back arter the ole man. But jest as I reached the fort, I heered a loud yellin' an' whoopin', an', lookin' back, I seed the settlers comin' out of the woods, with the Injuns clost behind 'em. Thar war, as nigh as I could guess, 'bout two hundred red-skins, an' not more 'n twenty white fellers; so, in course, thar war n't ne 'arthly use to think of fightin' in cl'ar open ground. The settlers war comin' as fast as their hosses could

fetch 'em, an' the Injuns war clost arter 'em, in-
tendin' to kill or captur' 'em all afore they could
reach the fort. I seed the ole man among the set
tlers, an' made up my mind that he war safe, fur
he rid a good hoss, when, all to onct, he dropped his
rifle, throwed up his hands, an' fell from his saddle
The settlers kept on; fur, in course, they could n't
help him, an' the ole man tried to foller 'em; but
I seed him pulled down an' tomahawked, 'bout two
hundred yards from the fort, by a young Injun,
whom, from his bar's claws, an' other fixins, I tuk
to be a chief. My ole shootin' iron war good fur
that distance, so I drawed up and blazed away.
But my hand trembled, an' I seed that Injun make
off with the ole man's scalp. That war a long
time ago, youngsters; but I can see that varlet
yet, an' hear the yell he give as he shook the scalp
at us in the fort, an' ran back into the woods. Of
them twenty men that war in the fight, 'bout a
dozen rode safe into the fort. The others war
massacreed afore our very eyes, an' we could n't
help 'em.

"Wal, the Injuns stayed round in the edge of
the tim'er fur 'bout two hours, yellin' an' firin' at
us; but, knowin' that they could not take the fort—

fur they tried that twice—they all set up a yelp
an' put off, burnin' every thing as they went. It
war a sad day fur that settlement. Nigh every
family war mournin' fur. somebody; but I war
wusser off nor any of 'em. My mother carried a
heap of years on her shoulders, an' when she seed
the ole man pulled down an' scalped, it gave her a
shock she never got over. We buried them both
nigh the fort, an' arter stayin' round fur a week or
two, I sot out with a party of trappers fur our ole
huntin' grounds on the Saskatchewan. I never
forgot that young Injun, an' all I keered fur or
thought 'bout, war to meet him. I jest knowed
that I should find him ag'in some day, an' if I had
met him among his tribe, with hundreds of his
friends standin' round, I would have knowed him.

" Wal, as I war sayin', I sot out with this party
of trappers, an' it war on the Saskatchewan that I
fust diskivered this chestnut king that I had made
up my mind to have. I follered him a'most all
winter, an' the more I seed him run, the more I
wanted to ketch him. I 'tended to my shar' of
the trappin', but every chance I got I war arter
them hosses. At last they put off somewhar, an'
I never seed 'em ag'in. I could n't think what had

'come on 'em, but I knowed that they had gone
clean out of the country, an' that I should have to
look fur another hoss, an' give up all hopes of
ketchin' the chestnut.

"When spring opened, an' it come good trav-
elin', we held a council, an' settled it that we
should start fur the fort to onct. We war in a
hurry to get away, too, fur some of our fellers had
seen Injun sign 'bout two miles from the camp ;
so, one mornin' we sot out to gather up our traps.
I had 'bout five mile to go to reach my trappin'
ground, so I rode off on a gallop. I went along
mighty keerless, fur I did n't b'lieve what them
fellers had said 'bout seein' Injun sign, but I soon
larnt that ole trappers never get fooled 'bout sich
things. I had n't gone more 'n a mile from the
camp, when, whizz! something whistled by my
head, an' went chuck into a tree on the other side
of me. It war an arrer, an' afore I could look
round to see whar it come from, I heered a yell,
an' the next minit a hoss popped out of the
bushes, an' came t'wards me. An Injun war on
his back, an' in one hand he carried a long spear,
an' with the other he held his bow an' guided
his hoss. As soon as he got cl'ar of the bushes,

he p'inted that spear straight at my breast, an'
came at me, full jump. I war a youngster then.
I hadn't been in as many rough-an'-tumble fights
with wild Injuns as I have been since, an' I would
have give all the spelter I had trapped that win-
ter if I had been safe in camp. These war the
fust thoughts that went through my mind. But
arter I had tuk jest one good look at the Injun
an' his hoss, I wouldn't have been away from thar
fur nothin'. The Injun war the young chief that
had rubbed out my ole man, an' the hoss war the
chestnut king—the very one I had been tryin' to
ketch fur a'most a year. So, you see, I had two
things to work fur. Fust, I had swore to have
that Injun's scalp; next, I wanted that hoss; an'
I made up my mind that I wouldn't leave that 'ar
place till I had 'em both. The young chief war
so clost to me that I didn't have time to shoot,
so I sot still in my saddle, an' when I seed the
p'int of the spear 'bout two foot from my breast,
I stuck out my rifle an' turned the we'pon aside.
Then, jest as the Injun war goin' by me, I ketched
him by the scalp-lock, quicker nor lightnin', an'
pulled him from his hoss. My own hoss warn't
trained wuth a plug o' tobacker, an', skeered by

the fuss, an' the Injuns yellin', he give a jump, an'
the fust thing I knowed, me an' the young chief
war rollin' on the ground together. I've had one
or two wild savages by the top-knot since then,
but I never got hold of a chap of his size that war
so strong an' wiry. When I fust ketched him, I
allowed to rub him out easy, fur I war purty good
on a rough-an'-tumble, an' it war n't every body
that could take my measure on the ground; but
when I ketched that Injun, I found that I had come
acrost a varmint. We fell side by side, I all the
while hangin' on to his har; but afore I could think
whar I war, or what a doin', I found the young
chief on top of me; an', both his hands bein' free,
he commenced feelin' fur his knife. In course I
could n't allow that, so I ketched one of his arms,
which he twisted out of my grasp, as easy as though
I had no strength at all. I tried this two or three
times, but findin' that I could n't hold him, I fast-
ened on his belt which held the knife, an', with one
jerk, tore it loose, an' flung it over my head. The
Injun, findin' that his we'pon war gone, whooped
an' yelled wusser nor ever. We war on even
terms now, fur my knife war under me, an' neither
of us could git at it. Then I began tryin' to git

him off me; but it war no use, an' the Injun findin'
that I breathed hard, held still an' quiet, hopin'
that I would soon tire myself out, an' then he
would have no trouble in gittin' away from me.
But I war layin' my plans all this while, an',
watchin' the Injun clost, I ketched him off his
guard, an' went to work in 'arnest. By the way
that chap kicked an' yelled, I guess he thought I
had only been foolin' with him afore, an' the way
he did fight war n't a funny thing fur me to think
of jest then. But it war no use. I thrashed
around till I got hold of my knife, an', in a minit
arter that, the young chief had give his last yell.
Arter bein' sartin that he was done fur, I jumped
up an' run t'wards the mustang, which had stood a
little way off watchin' the fight, as though he war
wonderin' who would come out at the top of the
heap. I ketched him easy, an' arter takin' the
young Injun's top-knot, I picked up his we'pons—
here's one of 'em, youngsters."

As the trapper spoke, he drew his hatchet from
his belt and handed it to Archie, who sat nearest
him. The boys remembered that the first time
they met old Bob, they had noticed that his hatchet
was different from any they had ever seen. The

blade was long and narrow, and as keen as a razor. The back part of the hatchet was hollow, as was also the handle, and thus the weapon could be made to answer the purpose of a pipe. The handle was also ingeniously carved, but was so worn by long and constant usage, that the figures upon it could not be distinguished. The travelers had often noticed that the old trapper was very particular about his "tomahawk," as he invariably called it; but now that they knew its history, they did not wonder that he considered it worth preserving. When the boys had examined the weapon to their satisfaction, they returned it to old Bob, who continued:

"Wal, arter I had tuk the young chief's scalp an' we'pons, (I had his knife, too, but I lost that in the Missouri River by bein' upset in a canoe,) I jumped on my new hoss, and rode t'wards the camp, leavin' my ole mustang to go where he pleased. When I reached our fellers, I found 'em all busy packin' up. They had diskivered signs of a large party of Injuns, an' they said that the sooner we got away from thar the better it would be fur us. We traveled all that night an' all the next day, an' got safe off. I had the laugh on my side

then, fur 'em fellers all said I could n't never put
a bridle on the chestnut king; an' when I told 'em
my story 'bout the young chief, you ought to seed
them open their eyes. I had n't been fooled 'bout
the good pints of that ar' hoss, fur he war a crit-
ter that suited me exactly. He carried me safe
through many a fight with grizzly bars an' Injuns;
but, finally, I lost him but a few miles from whar
I fust seed him—on the Saskatchewan. I never
trapped on that river yet without losin' somethin'.
I have lost two chums thar; throwed away four or
five winter's work—or jest the same as throwed it
away, fur all my furs war captur'd by the Injuns,
an' thar I lost this hoss."

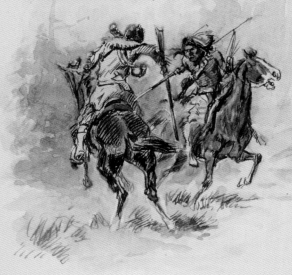

CHAPTER XVIII.

Old Bob's Adventure.

HE old trapper paused for a moment to refill his pipe, and then continued—

"I went out as usual with a party of trappers, fur in them days it war n't no way safe fur a feller to go thar alone. We war a'most sartin to be chased by the Injuns, but them as got away with a hul skin, allers went back as soon as they could make up a comp'ny, fur it war thar the best trappin' war to be found.

"If all the red-skins we have rubbed out thar could come to life ag'in, I reckon thar would be lots of 'em, an' if all our poor fellers who have had thar har raised on the plains of that same river, could come back, you'd see a heap of fine trappers. An' if me an' Dick could have all the furs we have lost thar, I'll allow it would keep us in

pipes an' tobacker fur a year or two. In them
days, a feller could git a good rifle fur a beaver or
otter skin, an' a fust rate hoss fur two or three
mink skins. Our furs war the only thing we had
to depend on to buy us a new outfit; so when we
lost all our winter's work, it war n't a thing to
laugh at.

"Wal, as I war sayin', I went out with this party
of fellers, an', as usual, not the least bit of Injun
sign did we see durin' the winter. As a gen'ral
thing the red-skins do n't run 'round much in cold
weather—leastways, they do n't go fur from their
camps; but by the time the snow is off the ground,
they ar' well-nigh out of grub, an' have to start
out on their huntin' expeditions. The Saskatche-
wan war a good place fur them to come to, fur
thar war plenty of game; but the country war n't
big enough for them an' us; so when they begun
comin' in, it war high time fur us to be goin' out.
Thar war five of us in the party, an' as every man
knowed his own bisness, by the time spring come
we had as much spelter as four hosses could pack
away. When the snow commenced goin' off, we
kept a good lookout fur Injuns—fur the trappin'
war so fine we did n't want to leave so long as it

war safe to stay—an', one mornin', as I war comin' in from tendin' to my traps, I seed whar two Injuns had crossed the creek. That war enough fur me, so I put for the camp, but did n't find nobody thar. The fellers war all out tendin' to their bisness; an', in course, I war n't goin' away without 'em; so I packed up my spelter ready fur the start, and while waitin' fur 'em, kept sharp watch on all sides fur Injuns. 'Bout noon I heered a hoss comin', an', in a few minits, up rid one of our fellers with his huntin' shirt all bloody. As soon as I seed him, I knowed that the game war up.

"'Bob!' says he, 'Get away from here to onct. Bill Coffee is done fur (that war his chum), an' you can see how nigh they come to rubbin' me out too. Some varlet sent an arrer clean through my arm. Hand me my pack o' furs, and let 's be off to onct, I tell you.'

"This man—Bill Simons his name war—war the oldest an' bravest man in our comp'ny, an' he war our leader. Although I did n't like the idee of leavin' them fellers out thar in the woods with them Injuns—fur every one of 'em had done me a kindness—I knowed I could n't do them no good by stayin'; fur, when Bill Simons deserted his own

brother, thar war n't no use of any body's tryin' to
help him. So I handed Bill his furs, grabbed up
my own, jumped on my hoss, an' we started. It
war no light load them hosses had to carry, fur
our spelter war a'most as heavy as we war. But
we could n't think of leavin' 'em behind without
makin' one effort to save 'em, fur we had worked
hard fur 'em, an' did n't want 'em to fall into the
hands of them lazy Injuns. As we rid along, we
made up our minds that we would stick together
as long as we could, an' that we would n't drop
our furs as long as we seed the least chance of
escapin' with 'em. But if we had knowed any
thing, we would have throwed away them packs to
onct, fur hangin' on to 'em so long was jest the
very thing that got us ketched. We run our
hosses with them heavy loads, till they war clean
done out; an' when the Injuns got arter us, they
war a'most ready to drop. Wal, as I war sayin',
we rid along fur 'bout two mile, keepin' a good
lookout on all sides fur Injuns, an', finally, we seed
'em behind us. Thar war 'bout twenty of 'em, an'
as soon as I sot eyes on 'em, I somehow knowed
that we war ketched.

"'Bob,' said Bill, turnin' to me, 'our scalps ar'
15

wuth more nor this spelter. It is time to run in 'arnest now.'

"He throwed down his pack, as he spoke, an' then his hoss went faster. But I, bein' young an' foolish, did n't like the idee of losin' my winter's work; so I held on to my pack, till, findin' that Bill war leavin' me behind, I throwed it away Thar war our eight months' wages gone. We had worked hard an' froze among the snows of the mountains fur nothin'. But we had n't gone fur afore we diskivered that we had oughter throwed 'em away long ago. Both our hosses run as though they had traveled all day, an' it war plain as bar's ears that they could n't go much further. Every time we looked back we seed that the Injuns war gainin' on us fast, an' the way they yelled told us that they, too, knowed that they would soon have us. I looked t'wards Bill, an' although I could read in his face that he knowed we war ketched, he did n't seem the least bit skeary. He had been in jest such scrapes afore. He had often been a pris'ner, but he war strong as a hoss, could run like a skeered deer, an' had allers succeeded in gittin' away from the Injuns at last. I, howsom- ever, had never been in the hands of the red-skins,

but I knowed, from the stories I had often heered, that they did n't treat a feller very kind, an' this set me to thinkin'. The Injuns knowed Bill, an' would n't they know me too? The young chief I had rubbed out b'longed to that same tribe, an' would n't his friends 'member the hoss, an' the knife, an' tomahawk I carried in my belt? I could throw the we'pons away, an', arter thinkin' a leetle, I did. I unbuckled my belt, an', jest as we went over a swell out of sight of the Injuns, I dropped knife, tomahawk, an' all, hopin' that the red-skins would never find 'em; fur I knowed that if they thought I had ever rubbed out any of the tribe, I would ketch the wust kind of punishment.

"Wal, all this while the Injuns had been gainin' on us, fur, the further we went, the slower our hosses run, an' all the whippin' an' poundin' we could do, did n't make them go no faster. They war well-nigh tuckered out. Purty quick I see Bill turn in his saddle an' draw up his ole shootin' iron. He war bound to die game. I watched the shot, an' could n't help givin' a yell when I seed one of the varlets drop from his hoss. The Injuns had all this while been ridin' clost together; but findin' that we war goin to begin shootin', they

scattered, an' throwed themselves flat on their hosses
backs, so that we could n't hit 'em. But we war
sartin of our game, no matter how small a mark
we had to shoot at, an' when I fired, I seed an In-
jun an' his hoss come to the ground together. By
this time, Bill war ready ag'in, an' down come an-
other Injun.

"If our hosses had only been fresh, we could
have picked off the last one of 'em afore they
could have ketched us. But the varlets kept
gainin' all the time, an' purty quick they got nigh
enough to use their we'pons, an' the way the arrers
whistled 'bout our heads war n't pleasant, now I
tell you. But we kept shootin' at 'em as fast as
we could load up, bringin' down an Injun at every
pop—till some chap sent his arrer into my hoss's
side—an' the next minit I war sprawlin' on the
ground. Bill kept on, but he had n't gone fur
afore he got an arrer through his neck, which
brought him from his saddle, dead. I jest seed
this as I war tryin' to get up; fur my hoss had
fell on my leg, an' war holdin' me down. Jest
arter Bill fell, the Injuns come up an' I war a
pris'ner. I could n't tell you how I felt, young-
sters I had heered enough to know that much

depended on my showin' a bold front; but it takes a man of mighty strong nerve to look a dozen yellin', scowlin' Injuns in the face, without onct flinchin'. Howsomever, I kept a leetle courage 'bout me, I guess, fur when one chap jumped, an' drawed his bow with an arrer p'inted straight at my breast, I looked him in the eye without winkin'; an' when another ketched me by the har, an' lifted his tomahawk as if he had a good notion to make an end of me to onct, I stood as still an' quiet as though I didn't see him. Arter this had been goin' on fur a while, the Injuns seemed to grow tired of it, fur my hands war bound behind my back, an' one feller fetched up Bill's hoss, an' war goin' to put me on him, when the critter, bein' clean tired out, give a grunt an' lay right down on the prairy. The Injuns seemed to think the hoss war no 'count, fur they turned him loose, an' I war lifted on to a mustang behind one of the savages. I didn't think much of this at the time, but I arterward had reason to be glad that the varlets had left Bill's hoss out thar on the prairy.

"It war 'bout five mile to the place whar the Injuns had made their camp, an' while on the way thar I warn't bothered at all, fur they seed that I

war n't skeered easy. When we reached the vil-
lage—which must have had nigh two hundred In-
juns in it—I found that I war n't the only pris'ner,
fur thar war Pete Simons, Bill's brother, tied to a
post in the middle of the camp, an' he war sur-
rounded by men, women, and young uns, who war
beatin' him with sticks, an' tormentin' him every way
they knowed how; but findin' that they could n't
make Pete show fear—fur that war something he
did n't have in him—they left him, when I came
up, and pitched into me. I did n't mind 'em much,
howsomever, although I *did* wince jest the least
bit when one feller struck at me with his toma-
hawk, and jest grazed my face; but they did n't
see it; an' purty quick one big feller ketched me
by the har, an', arter draggin' me up to the post,
tied me with my back to Pete's. It then wanted
'bout three hours of sundown, an' the Injuns, ar-
ter holdin' a leetle council, made up their minds
to have some fun; so they untied me an' Pete, an'
led us out on the prairy 'bout three or four hun-
dred yards, an' thar left us. We looked back an'
seed the Injuns all drawed up in a line, with their
we'pons in their hands, an' knowed that the varlets
had give us a chance to run for our lives. In course

they didn't mean fur us to git away, but they wanted the fun of seein' us run, never dreamin' but some of their fleet braves would ketch us afore we had gone fur. I never looked fur 'em to give us sich a chance fur life as that, an' I made up my mind that I would learn 'em to think twice afore they give a white trapper the free use of his legs ag'in. I a'most knowed I war safe, but I felt shaky 'bout Peter, fur the Injuns had shot him with two arrers afore they ketched him, an' he war hurt bad. I didn't think he could run far—nor he didn't, neither; fur when we shook hands an' wished each other good luck, he said to me, 'Bob, I wish I had my rifle.' He meant by that, if he had his ole shootin' iron in his hands, he wouldn't die alone; he would have fit the Injuns as long as he could stand. Wal, as I war sayin', we shook hands an' bid each other good-by, an' jest then I heered a yell. I jumped like a flash of lightnin', an' made t'wards a little belt of tim'er which I could see, 'bout two miles acrost the prairy. I war runnin' fur my life, an' I reckon I made the best time I knowed how. I soon left poor Pete behind, an', when I had gone about a mile, I heered a yell, that tol l me as plain as words, that he had been ketched.

I never stopped to look back, but kept straight ahead,
an' in a few minits more I war in the woods. The
yellin' of the Injuns had been growin' louder an'
louder, so I knowed that they were gainin' on me,
an' that if I kept on they would soon ketch me; so,
as soon as I found myself fair in the tim'er, I turned
square off to the right, an' takin' to every log I could
find, so as to leave as leetle trail as possible fur them
to foller, I ran 'bout a hundred yards further, an'
then dived into a thick clump of bushes, whar I hid
myself in the leaves an' brush. I had kinder both-
ered the varlets, for a leetle while arter, they came in-
to the woods, an' went on through, as if they thought
I had kept on t'wards the prairy. But I knowed
that they would n't be fooled long ; an' when I heered
by their yellin' that they had left the woods, I crawled
out of the bushes to look up a better hidin'-place
Arter listenin' an' lookin', to be sartin that thar
war no Injuns 'round, I ag'in broke into a run, an'
finally found a holler log at the bottom of a gully,
whar I thought I had better stop ; so I crawled into
the log, an' jest then I heered the Injuns coming
beck. They knowed that I war hid somewhar in
the tim'er, an' they all scattered through the woods,

hopin' to find me afore it 'come dark—yellin' all
the while, as though they didn't feel very good-na-
tured 'bout bein' fooled that ar' way. I knowed that
they couldn't foller my trail easy, but thar war so
many of 'em, that I war afraid somebody might hap-
pen to stumble on my hidin'-place. But they didn't;
an' arter awhile it 'come dark, an' the varlets had
to give up the search. I waited till every thing war
still, an' then crawled out of my log, and struck fur
the prairy. I warn't green enough to b'lieve that
they war all gone, fur I knowed that thar war In-
juns layin' 'round in them woods watchin' an' wait-
in' fur me. In course I didn't want to come acrost
none of 'em, fur I had no we'pon, and I would have
been ketched sartin; so I war mighty keerful; an'
I b'lieve I war two hours goin' through the hundred
yards of woods that lay atween me an' the prairy.
When I reached the edge of the tim'er, I broke
into a run. If thar war any Injuns 'round, they
couldn't see me, fur the night war dark; an' they
couldn't hear me, neither, fur my moccasins didn't
make no noise in the grass. I kept on, at a steady
gait, fur 'bout two hours, an' finally reached the place
whar I war captur'd. Arter a leetle lookin' and

feelin', I found my belt and we'pons. I felt a heap
better then, fur I had something to defend myself
with; but still I didn't feel like laughin', fur I war
afoot, an', havin' no rifle, I couldn't think how I war
to git grub to eat. But I war better off nor while
I war a pris'ner 'mong the Injuns; so I knowed I
hadn't oughter complain. Arter takin' one look
at poor Bill, whom the Injuns, arter havin' scalped,
had left whar he had fallen, an' promisin' that ev-
ery time I seed a Blackfoot Injun I would think of
him, I ag'in set out. Arter I had gone 'bout half
a mile further, the moon riz, an', as I war running
along, I seed something ahead of me. I stopped
to onct, fur I didn't know but it might be a Injun;
but another look showed me it war a hoss. He war
feedin' when he fust seed me, but, when he heered
me comin', he looked up, an' give a leetle whinny
that made me feel like hollerin'. It war Bill Si-
mons's hoss. How glad I war to see him! An' he
must a been glad to see me, too, fur he let me ketch
him; an' when I got on his back, I didn't keer, jest
then, fur all the Injuns on the plains. The critter
had had a good rest, an', when I spoke to him, he
started off just as lively as though he war good fur

a hundred mile. Wal, I rid all that night, an', 'arly
tne next mornin', I found myself nigh a patch of
woods whar we allers made our camp when goin'
to an' from the Saskatchewan, an' I thought I would
stop thar and git a leetle rest, fur I war tired an'
hungry. So I rid through the woods, an', when I
come in sight o' our ole campin' ground, I seed
something that made me feel like hollerin' ag'in;
an' I *did* holler; fur thar war two of our comp'ny—
'he only ones that 'scaped 'sides me—jest gettin'
ceady to start off. They stopped when they seed
me—an', youngsters, you may be sartin that we
war glad to meet each other ag'in. One of 'em
war Bill Coffee, who I thought war dead. He war
bad hurt, but he got off without losin' his har, an'
he felt mighty jolly over it. Arter they had told
me 'bout their fight with the Injuns—an' they jest
did get away, an' that war all—I told 'em 'bout Bill
Simons bein' killed, and how me an' Pete had run
a race with the varlets, an' we all swore that the
Blackfeet wouldn't make nothin' by rubbin' out
them two fellers. I stayed thar long enough to
rest a little an' eat a piece of meat that one of 'em
give me, an' then we all sot out fur the fort, which

we reached all right. We laid 'round fur 'bout a
month, an' then—would you b'lieve it?—we three
fellers made up another comp'ny, an' put fur the
Saskatchewan ag'in. None of us ever forgot our
promise, an' every time we drawed a bead on a
Blackfoot, we thought of Bill an' Pete Simons."

CHAPTER XIX.

Homeward Bound.

HE travelers remained at the "ole bar's hole" three weeks, instead of one, as they had at first intended. Game of every description was plenty; there were no Indians to trouble them; in short, they were leading a life that exactly suited the boys, who were in no hurry to resume their journey, which was becoming tiresome to them. Besides, their supply of bacon was exhausted, and the trappers undertook to replenish the commissary. This they did by "jerking" the meat of the buffaloes that had been killed during the hunt in which Frank had taken his involuntary ride. They cut the meat into thin strips, and hung it upon frames to dry—the sun and the pure atmosphere of the prairie did the rest. The meat was thoroughly cured without

smoke or salt, and although the boys did not rel-
ish it as well as the bacon, they still found it very
palatable. To Dick, it was like meeting with an
old friend. He had always been accustomed to
jerked Buffalo meat, and he ate great quantities
of it, to the exclusion of corn-bread and coffee, of
which he had become very fond.

In addition to this, the gray mustang demanded
a large share of their attention. He was very un-
ruly, extremely vicious, and attempted to use his
teeth or heels upon every thing that approached
him. But these actions did not in the least intimi-
date Dick, who was a most excellent horseman;
and, after several rides over the prairie, coupled
with the most severe treatment, he succeeded in
subduing the gray, which was turned over to his
young master, with the assurance that he was "a
hoss as no sich ole buffaler hunter as Sleepy Sam
could run away from."

This declaration was instantly resisted by Ar-
chie, who forthwith challenged Frank to a race;
but it was not until the latter had fully satisfied
himself that the mustang was completely conquered
that he accepted the proposition. When he had
been robbed of his horse, Frank had lost some

thing that could not again be supplied, and that
was his saddle. As for a bridle, he soon found
that the trapper's lasso twisted about the gray's
lower jaw, answered admirably; but it was a long
time before he could bring himself to believe that
his blanket could be made to do duty both as sad-
dle and bed. After a week's practice, however,
he began to feel more at home on his new horse;
and, one morning, as he rode out with his cousin,
he informed him that he was prepared for the race.
Archie, always ready, at once put Sleepy Sam at
the top of his speed; but the gray king had lost
none of his lightness of foot during his captivity,
and before they had gone fifty yards he had car-
ried Frank far ahead. Race after race came off
that day, and each time Sleepy Sam was sadly
beaten. Archie was compelled to acknowledge the
gray's superiority, and declared that he " would n't
mind camping with Black Bill himself if he could
be certain of no worse treatment than Frank had
eceived, and could gain as good a horse as the
g ay king by the operation.'

The mustang having been thoroughly broken to
sad. 'e, and the travelers supplied with meat, there
was 1 thing now to detain them at the cave. So,

one morning Dick harnessed his mules, and they prepared to resume their journey. Before starting, however, the boys explored the "ole bar's hole" for the twentieth time, and as long as they remained in sight, they turned to take a long, lingering look at the place which was now associated with many exciting adventures.

Instead of traveling back to the road the train had taken, the trapper led them southward, and, after a long and tedious journey through the mountains, they reached Bridger's Pass, and a few days afterward they arrived at a fort of the same name. They camped there one night, and then turned their faces toward Salt Lake City, which they reached in safety. Mr. Winters led the way to a hotel, where an excellent dinner was served up for them. After passing more than two months in the saddle, subsisting upon the plainest food, it is no wonder that the boys were glad to find themselves seated at a table once more. Fresh meat and vegetables of all kinds disappeared before their attacks, and they finally stopped because they were ashamed to eat more. After dinner, being informed by their uncle that they would remain in the city until the following day, in order to give the trappers

time to lay in a fresh supply of provisions, the boys
started out to see the sights. Evidences of pros-
perity met their eyes on every side. Some of the
buildings were elegant, the streets broad and clean,
and filled with vehicles. Wagon trains were con-
stantly coming and going, and the principal busi-
ness seemed to be to supply these with provisions.
Archie thought it must be a splendid place to live
in, so near good hunting grounds; but he could
not help glancing pityingly toward a youth about
his own age, whom they met on the street, and won-
dering "how many mothers that poor fellow had to
boss him around."

When it began to grow dark they returned to
their hotel, where they retired early. They thought
they could enjoy a good night's rest in a comfort-
able bed, but their expectations were not realized.
They could not go to sleep. First, they thought
the quilts were too heavy, and they kicked them
off on the floor. Then the mattress was too soft—
they could scarcely breathe—and after rolling and
tossing for half the night, they spread the quilts
on the floor, and there slept soundly until morning.

Their journey through Utah and Nevada into
California, was accomplished without incident
16

worthy of note. The boys hunted a little now
and then, in company with the trappers; raced
their horses every day, and Archie found oppor-
tunities to make a collection of relics, that fully
reconciled him to the loss of those of which Frank
had been robbed the night he camped with the
outlaw. There was no lack of fun and excitement,
but they had been so long in the saddle that they
began to grow weary of their journey, and heartily
wished themselves at the end of it.

In due time they arrived at Sacramento, where
was located a large business house in which Mr.
Winters was interested. They secured rooms at
a hotel, and the next morning found the boys fresh
and eager for the sights of the city. They met
uncle James and the trappers at the breakfast
table, and the former proceeded to unfold his pro-
gramme.

"We shall probably remain in Sacramento two
or three weeks," said he, "or, at least until I can
settle up a few important business matters, and
then we'll set out again. Our life in the saddle
is over for the present. When we resume our
journey we shall travel by stage and steamer."

"Wal—no, I reckon not," said Dick, quickly,

"leastways not me an' my chum, here. I'd a heap sooner foot it."

"Why, there's no danger," said Archie.

"Now, you need n't talk, little 'un," replied the trapper, "'cause it won't do no arthly good, whatsomever. We jest aint a goin' to do it."

"Well, then," said Mr. Winters, "suppose you and Bob take the boys' horses and make the journey by land. Our home for the next six or eight months," he added, turning to his nephews, "will be in the southern part of California, sixty miles from San Diego. Dick and Bob have expressed a desire to remain with us until we return to the States, and so I have hired them."

"What for?" asked Frank. "To hunt and trap for you?"

"No, to take care of cattle."

"An' to keep an eye on you youngsters," chimed in old Bob. "You'll be fightin' grizzly bars, an gettin' stampeded with buffaler if you aint watched mighty close."

"But suppose Dick can't find his way to San Diego?" said Archie.

"You need n't be oneasy," laughed the trapper. "Mebbe you'd think it queer if I should tell you

that me an' ole Bill Lawson have hunted over near every mile of this country. If you live to get to San Diego—which I don't much look fur, seein' that you are goin' to travel on one of them steamboats—you'll find me an' Bob waitin' fur you."

This plan having been decided upon, the trappers prepared to start immediately. They did not feel at home in the city, and seemed impatient to get out of it. Dick took leave of the boys as though he never expected to see them again, and then mounted Frank's horse and galloped down the street, leading sleepy Sam by the bridle.

Frank and Archie remained in Sacramento nearly three weeks. They enjoyed themselves in various ways, but were not sorry when uncle James told them that he was ready to resume the journey. They went by stage to Benecia, and thence by boat to San Francisco. There they remained a few days, to explore the city, and then took passage on board a mail steamer for San Diego. They reached their destination after a pleasant voyage, and almost the first man they saw when they stepped upon the wharf, was Dick Lewis, who seemed immensely relieved to find that they had accomplished their journey in safety.

The party spent the night at the hotel, and the next morning, bright and early, set out on horseback for Mr. Winters' ranche, where they arrived about supper time. Here the boys again found themselves surrounded by new scenes. In less than half an hour they had made a thorough examination of their new quarters, and come to the conclusion that during the next six months they were doomed to lead a very dull life.

"We shall see no fun here," said Archie, as he and his cousin went into the room that had been assigned to them, to get ready for supper. "Dick and Bob will be kept busy attending to the stock; there are no boys in the country; the nearest house is four miles distant; it is so hot one can scarcely stir out of doors, and we can do nothing but sit and mope in the house."

These were Archie's first impressions. Before he had been long on the ranche, he discovered that life in California was not so dull and uneventful as he had imagined it to be. He had adventures, and more than he wanted; and what they were shall be told in FRANK AMONG THE RANCHEROS.

FAMOUS STANDARD
JUVENILE LIBRARIES.

ANY VOLUME SOLD SEPARATELY AT $1.00 PER VOLUME

(Except the Sportsman's Club Series, Frank Nelson Series and
Jack Hazard Series.).

Each Volume Illustrated. 12mo. Cloth.

HORATIO ALGER, JR.

THE enormous sales of the books of Horatio Alger, Jr.,
show the greatness of his popularity among the boys, and
prove that he is one of their most favored writers. I am told
that more than half a million copies altogether have been
sold, and that all the large circulating libraries in the country
have several complete sets, of which only two or three vol-
umes are ever on the shelves at one time. If this is true,
what thousands and thousands of boys have read and are
reading Mr. Alger's books! His peculiar style of stories,
often imitated but never equaled, have taken a hold upon the
young people, and, despite their similarity, are eagerly read
as soon as they appear.

Mr. Alger became famous with the publication of that
undying book, "Ragged Dick, or Street Life in New York."
It was his first book for young people, and its success was so
great that he immediately devoted himself to that kind of
writing. It was a new and fertile field for a writer then, and
Mr. Alger's treatment of it at once caught the fancy of the
boys. "Ragged Dick" first appeared in 1868, and ever since
then it has been selling steadily, until now it is estimated
that about 200,0co copies of the series have been sold.

—Pleasant Hours for Boys and Girls.

A writer for boys should have an abundant sympathy with them. He should be able to enter into their plans, hopes, and aspirations. He should learn to look upon life as they do. Boys object to be written down to. A boy's heart opens to the man or writer who understands him.

—From *Writing Stories for Boys*, by Horatio Alger, Jr.

RAGGED DICK SERIES.

6 vols. BY HORATIO ALGER, JR. $6.00

Ragged Dick. Rough and Ready.
Fame and Fortune. Ben the Luggage Boy.
Mark the Match Boy. Rufus and Rose.

TATTERED TOM SERIES—First Series.

4 vols. BY HORATIO ALGER, JR. $4.00

Tattered Tom. Phil the Fiddler.
Paul the Peddler. Slow and Sure.

TATTERED TOM SERIES—Second Series.

4 vols. $4.00

Julius. Sam's Chance.
The Young Outlaw. The Telegraph Boy.

CAMPAIGN SERIES.

3 vols. BY HORATIO ALGER, JR. $3.00

Frank's Campaign. Charlie Codman's Cruise.
 Paul Prescott's Charge.

LUCK AND PLUCK SERIES—First Series.

4 vols. BY HORATIO ALGER, JR. $4.00

Luck and Pluck. Strong and Steady.
Sink or Swim. Strive and Succeed.

LUCK AND PLUCK SERIES—Second Series.
4 vols. $4.00

Try and Trust. Risen from the Ranks.
Bound to Rise. Herbert Carter's, Legacy.

BRAVE AND BOLD SERIES.
4 vols. BY HORATIO ALGER, JR. $4.00

Brave and Bold. Shifting for Himself.
Jack's Ward. Wait and Hope.

NEW WORLD SERIES.
3 vols. BY HORATIO ALGER, JR. $3.00

Digging for Gold. Facing the World. In a New World.

VICTORY SERIES.
3 vols. BY HORATIO ALGER, JR. $3.00

Only an Irish Boy. Adrift in the City.
 Victor Vane, or the Young Secretary.

FRANK AND FEARLESS SERIES.
3 vols. BY HORATIO ALGER, JR. $3.00

Frank Hunter's Peril. Frank and Fearless.
 The Young Salesman.

GOOD FORTUNE LIBRARY.
3 vols. BY HORATIO ALGER, JR. $3.00

Walter Sherwood's Probation. A Boy's Fortune.
 The Young Bank Messenger.

RUPERT'S AMBITION.
1 vol. BY HORATIO ALGER, JR. $1.00

JED, THE POOR=HOUSE BOY.
1 vol. BY HORATIO ALGER, JR. $1.00

HARRY CASTLEMON.

HOW I CAME TO WRITE MY FIRST BOOK.

WHEN I was sixteen years old I belonged to a composition class. It was our custom to go on the recitation seat every day with clean slates, and we were allowed ten minutes to write seventy words on any subject the teacher thought suited to our capacity. One day he gave out "What a Man Would See if He Went to Greenland." My heart was in the matter, and before the ten minutes were up I had one side of my slate filled. The teacher listened to the reading of our compositions, and when they were all over he simply said : "Some of you will make your living by writing one of these days." That gave me something to ponder upon. I did not say so out loud, but I knew that my composition was as good as the best of them. By the way, there was another thing that came in my way just then. I was reading at that time one of Mayne Reid's works which I had drawn from the library, and I pondered upon it as much as I did upon what the teacher said to me. In introducing Swartboy to his readers he made use of this expression : "No visible change was observable in Swartboy's countenance." Now, it occurred to me that if a man of his education could make such a blunder as that and still write a book, I ought to be able to do it, too. I went home that very day and began a story, "The Old Guide's Narrative," which was sent to the *New York Weekly*, and came back, respectfully declined. It was written on both sides of the sheets but I didn't know that this was against the rules. Nothing abashed, I began another, and receiving some instruction, from a friend of mine who was a clerk in a book store, I wrote it on only one side of the paper. But mind you, he didn't know what I was doing. Nobody knew it ; but one

day, after a hard Saturday's work—the other boys had been out skating on the brick-pond—I shyly broached the subject to my mother. I felt the need of some sympathy. She listened in amazement, and then said : "Why, do you think you could write a book like that?" That settled the matter, and from that day no one knew what I was up to until I sent the first four volumes of Gunboat Series to my father. Was it work? Well, yes ; it was hard work, but each week I had the satisfaction of seeing the manuscript grow until the "Young Naturalist" was all complete.

—Harry Castlemon in the Writer.

GUNBOAT SERIES.

6 vols. By HARRY CASTLEMON. $6.00

Frank the Young Naturalist. Frank before Vicksburg.
Frank on a Gunboat. Frank on the Lower Mississippi.
Frank in the Woods. Frank on the Prairie.

ROCKY MOUNTAIN SERIES.

3 vols. By HARRY CASTLEMON. $3.00

Frank Among the Rancheros. Frank in the Mountains.
Frank at Don Carlos' Rancho.

SPORTSMAN'S CLUB SERIES.

3 vols. By HARRY CASTLEMON. $3.75

The Sportsman's Club in the Saddle. The Sportsman's Club
The Sportsman's Club Afloat. Among the Trappers.

FRANK NELSON SERIES.

3 vols. By HARRY CASTLEMON. $3.75

Snowed up. Frank in the Forecastle. The Boy Traders.

BOY TRAPPER SERIES.

3 vols. By HARRY CASTLEMON. $3.00

The Buried Treasure. The Boy Trapper. The Mail Carrier.

ROUGHING IT SERIES.

3 vols. By Harry Castlemon. $3.00

George in Camp. George at the Fort.
George at the Wheel.

ROD AND GUN SERIES.

3 vols. By Harry Castlemon. $3.00

Don Gordon's Shooting Box. The Young Wild Fowlers.
Rod and Gun Club.

GO=AHEAD SERIES.

3 vols. By Harry Castlemon. $3.00

Tom Newcombe. Go-Ahead. No Moss.

WAR SERIES.

6 vols. By Harry Castlemon. $6.00

True to His Colors. Marcy the Blockade-Runner.
Rodney the Partisan. Marcy the Refugee.
Rodney the Overseer. Sailor Jack the Trader.

HOUSEBOAT SERIES.

3 vols. By Harry Castlemon. $3.00

The Houseboat Boys. The Mystery of Lost River Cañon.
The Young Game Warden.

AFLOAT AND ASHORE SERIES.

3 vols. By Harry Castlemon. $3.00

Rebellion in Dixie. A Sailor in Spite of Himself.
The Ten-Ton Cutter.

THE PONY EXPRESS SERIES.

3 vol. By Harry Castlemon. $3.00

The Pony Express Rider. The White Beaver.
Carl, The Trailer.

EDWARD S. ELLIS.

EDWARD S. ELLIS, the popular writer of boys' books, is a native of Ohio, where he was born somewhat more than a half-century ago. His father was a famous hunter and rifle shot, and it was doubtless his exploits and those of his associates, with their tales of adventure which gave the son his taste for the breezy backwoods and for depicting the stirring life of the early settlers on the frontier.

Mr. Ellis began writing at an early age and his work was acceptable from the first. His parents removed to New Jersey while he was a boy and he was graduated from the State Normal School and became a member of the faculty while still in his teens. He was afterward principal of the Trenton High School, a trustee and then superintendent of schools. By that time his services as a writer had become so pronounced that he gave his entire attention to literature. He was an exceptionally successful teacher and wrote a number of text-books for schools, all of which met with high favor. For these and his historical productions, Princeton College conferred upon him the degree of Master of Arts.

The high moral character, the clean, manly tendencies and the admirable literary style of Mr. Ellis' stories have made him as popular on the other side of the Atlantic as in this country. A leading paper remarked some time since, that no mother need hesitate to place in the hands of her boy any book written by Mr. Ellis. They are found in the leading Sunday-school libraries, where, as may well be believed, they are in wide demand and do much good by their sound, wholesome lessons which render them as acceptable to parents as to their children. All of his books published by Henry T. Coates & Co. are re-issued in London, and many have been translated into other languages. Mr. Ellis is a writer of varied accomplishments, and, in addition to his stories, is the author of historical works, of a number of pieces of pop-

ular music and has made several valuable inventions. Mr. Ellis is in the prime of his mental and physical powers, and great as have been the merits of his past achievements, there is reason to look for more brilliant productions from his pen in the near future.

DEERFOOT SERIES.

3 vols. By EDWARD S. ELLIS. $3.00
Hunters of the Ozark. The Last War Trail.
Camp in the Mountains.

LOG CABIN SERIES.

3 vols. By EDWARD S. ELLIS. $3.00
Lost Trail. Footprints in the Forest.
Camp-Fire and Wigwam.

BOY PIONEER SERIES.

3 vols. By EDWARD S. ELLIS. $3.00
Ned in the Block-House. Ned on the River.
Ned in the Woods.

THE NORTHWEST SERIES.

3 vols. By EDWARD S. ELLIS. $3.00
Two Boys in Wyoming. Cowmen and Rustlers.
A Strange Craft and its Wonderful Voyage.

BOONE AND KENTON SERIES.

3 vols. By EDWARD S. ELLIS. $3.00
Shod with Silence. In the Days of the Pioneers.
Phantom of the River.

IRON HEART, WAR CHIEF OF THE IROQUOIS.

1 vol. By EDWARD S. ELLIS. $1.00

THE SECRET OF COFFIN ISLAND.

1 vol. By EDWARD S. ELLIS. $1.00

THE BLAZING ARROW.

1 vol. By EDWARD S. ELLIS. $1.00

J. T. TROWBRIDGE.

NEITHER as a writer does he stand apart from the great currents of life and select some exceptional phase or odd combination of circumstances. He stands on the common level and appeals to the universal heart, and all that he suggests or achieves is on the plane and in the line of march of the great body of humanity.

The Jack Hazard series of stories, published in the late *Our Young Folks*, and continued in the first volume of *St. Nicholas*, under the title of "Fast Friends," is no doubt destined to hold a high place in this class of literature. The delight of the boys in them (and of their seniors, too) is well founded. They go to the right spot every time. Trowbridge knows the heart of a boy like a book, and the heart of a man, too, and he has laid them both open in these books in a most successful manner. Apart from the qualities that render the series so attractive to all young readers, they have great value on account of their portraitures of American country life and character. The drawing is wonderfully accurate, and as spirited as it is true. The constable, Sellick, is an original character, and as minor figures where will we find anything better than Miss Wansey, and Mr. P. Pipkin, Esq. The picture of Mr. Dink's school, too, is capital, and where else in fiction is there a better nick-name than that the boys gave to poor little Stephen Treadwell, "Step Hen," as he himself pronounced his name in an unfortunate moment when he saw it in print for the first time in his lesson in school.

On the whole, these books are very satisfactory, and afford the critical reader the rare pleasure of the works that are just adequate, that easily fulfill themselves and accomplish all they set out to do.—*Scribner's Monthly.*

JACK HAZARD SERIES.

6 vols. By J. T. TROWBRIGE. $7.25

Jack Hazard and His Fortunes. Doing His Best.
The Young Surveyor. A Chance for Himself.
Fast Friends. Lawrence's Adventures.

———

ROUNDABOUT LIBRARY.

For Boys and Girls.

(97 Volumes.) **75c. per Volume.**

The attention of Librarians and Bookbuyers generally is called to HENRY T. COATES & CO.'S ROUNDABOUT LIBRARY, by the popular authors.

EDWARD S. ELLIS, MARGARET VANDEGRIFT,
HORATIO ALGER, JR., HARRY CASTLEMON,
C. A. STEPHENS, G. A. HENTY,
 LUCY C. LILLIE and others.

No authors of the present day are greater favorites with boys and girls.

Every book is sure to meet with a hearty reception by young readers.

Librarians will find them to be among the most popular books on their lists.

Complete lists and net prices furnished on application.

———

HENRY T. COATES & CO.

1222 CHESTNUT STREET

PHILADELPHIA